# BASIC DEVELOPING, PRINTING, ENLARGING IN COLOR

## CONTENTS

© Eastman Kodak Company, 1984
Standard Book Number 0-87985-326-3
Library of Congress Catalog Card No. 82-83285
**CAT No. 111 2762**

1

# GETTING STARTED

There's a great deal of satisfaction in creating good color pictures from your favorite color negatives or slides—images that you've exposed and possibly even processed yourself. This book tells you, step by step, how to make sharp, well-exposed, and well-composed color enlargements from color film. If you'd like to process your own color negatives or slides, there are sections that tell you what you'll need and direct you through the processes. Another section covers the essentials of printing color negatives, including determining proper color balance and exposure, and processing KODAK EKTACOLOR Papers. If you want to make color prints from your slides, there's a chapter that introduces to you the Kodak products available and gives some pointers on their use. Also included is a section on KODAK EKTAFLEX PCT Printmaking Products describing how to make beautiful color prints from both negatives and slides.

Anyone with a serious interest in photography can process color film and make color prints in his or her own darkroom. Most of the same equipment required for making black-and-white pictures—tank, enlarger, trays, timers, thermometer—will work fine for doing color work. You'll also need some color filters to control the color balance of the prints and a KODAK 13 Safelight Filter (amber).* For ease in maintaining processing consistency, you can invest in a tube processor or KODAK EKTAFLEX Printmaker, Model 8.

While this book will tell you all the things you need to know to process color film and make color prints, it is a *basic* book. For more detail and information on advanced techniques, read the KODAK Data Book *Printing Color Negatives* (E-66) or the KODAK Workshop Series book *Color Printing Techniques* (KW-16). These books are sold by photo dealers.

Now it's time to get started. The following chapters will help you discover the enjoyment of processing and printing your own pictures in color.

---

*The Kodak materials described in this publication are available from those dealers normally supplying Kodak products. Other materials may be used, but equivalent results may not be obtained.

# THE COLOR DARKROOM

## DARKROOM PLANNING

Since photographic films and papers are sensitive to light, you must handle them in a darkroom. How elaborate you make your color darkroom will depend primarily on your need, finances, and space. For processing color film, almost any makeshift arrangement will do. You need a totally dark room only while you're loading your film into a film-developing tank.

A good way to determine whether a room or closet is completely dark is to stay in it for 5 minutes with the lights out. If after this amount of time you still can't see a sheet of white paper placed against a dark background, the room passes inspection. You can make areas around doors lighttight by putting heavy cloth over cracks. Eliminate small light leaks with black masking tape.

If there is a fluorescent light in your darkroom, wait several minutes after turning it off before opening and handling photographic film or paper. Fluorescent tubes give off an invisible afterglow that can cause fogging of light-sensitive materials.

If you want to make color prints from color negatives or slides, you will want a well-equipped room that is conveniently arranged and properly heated, lighted, and ventilated. It should also have hot and cold running water (not necessary for KODAK EKTAFLEX Printmaking Products). Make sure that the only light in the room is supplied by the recommended safelight, and keep the photographic paper at least 4 feet (1.2 m)* from the safelight. (For specific recommendations on what safelights and bulb wattages to use and when to use them for color papers made by Kodak, see page 29.)

*Keep out light and dust by sealing cracks with heavy black tape.*

---

*For ease in reading, the metric equivalent is given once per value.

Total Darkness      1 minute       3 minutes       7 minutes

*Here are the results of the safelight test described above. This sheet of KODAK EKTACOLOR PLUS Paper was placed too close to the safelight. Note the fog buildup as exposure time to the safelight illumination increased.*

## You can make a simple safelight test as follows:

1. Set your enlarging easel to give 1/2-inch (13 mm) white borders for the paper size you'll use in the test.

2. Put a color negative into the enlarger. Be sure the clear borders of the negative are completely masked.

3. Size and focus the image on the easel.

4. With all safelights off, make a good-quality color print on photographic paper.

5. Keeping the safelights off, remove the enlarging paper from the easel and put it, emulsion side up, onto a flat surface wherever safelight illumination (when turned on) will generally be the brightest—for example, on a counter or sink top.

6. Cover one-fourth of the print with an opaque card and turn on all safelights. Expose the print to the safelight for 1, 2, and 4 minutes, in steps, covering an additional one-

fourth of the print with the opaque card for each step. This gives four steps with safelight exposures of 0, 1, 3, and 7 minutes on the white borders and superimposed on the image exposure. Process the print with the safelights turned off or in a daylight tube. If you're using a tube, be sure to load the paper also with the safelights turned off.

7. After the print is dry, check your results. If the print shows slight fogging of highlights in any of the safelight exposure areas, it is a warning to limit exposure to safelight illumination.

In planning your darkroom, the main objective is to arrange your equipment and materials for efficiency and convenience. One of the most important requirements is to provide for a flow of work that can be done in the least amount of time with minimum effort. Another consideration is cost. Here are some desirable features for darkroom design and some suggestions you should consider in setting up your own color darkroom.

## TEMPORARY SETUPS

For developing color film and making color prints, you can operate in an easily darkened kitchen, bathroom, or any other room that has running water, electrical outlets, and a good working surface. For night work, you don't have to be quite as concerned about light leaks; however, you should pull the shades or cover the windows with some opaque material to exclude light from streetlamps, car headlights, or nearby lighted windows. The kitchen is probably the most convenient place to set up a temporary color darkroom.

When space is not available for setting up a permanent darkroom so that you must work in a room regularly used for other purposes, darkroom convenience sometimes has to be sacrificed. However, always try to arrange your equipment to allow a smooth, convenient flow of work from your enlarger through the processing steps to drying the print. Group your equipment so that you can perform all operations with a minimum of steps, but allow sufficient working space.

It's helpful to have a table or other separate work area on which you can perform all the dry operations such as loading film tanks and paper tubes. This prevents water and solutions from splashing equipment and other dry materials. Set up all wet processing operations in or near the sink.

The convenience of using EKTAFLEX Printmaking Products is that only a limited amount of space is needed. The printmaker must be secured to a stable, level surface, but the process requires no chemical mixing, precise temperature monitoring, or running water.

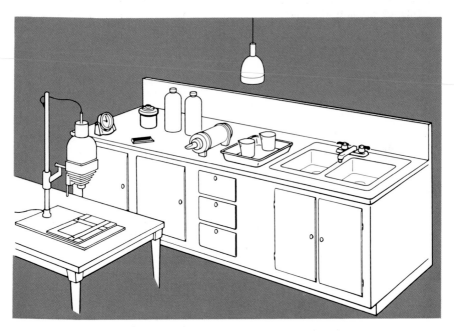

**Figure 1**  Temporary Darkroom

5

**CAUTION:** Some photographic chemicals, particularly acid solutions, may cause corrosion. To minimize the chances of damage to your sink and drainage system, use cold water to thoroughly wash the sink and flush the drain after each use.

Not all chemicals can be disposed through the sewer system, and certain chemicals should not be mixed during disposal. For more information refer to KODAK Publication No. J-52, *Disposal of Small Volumes of Photographic-Processing Solutions,* available free upon request from Eastman Kodak Company, Dept 412-L, 343 State Street, Rochester, New York 14650. Information on the disposal of KODAK EKTAFLEX PCT Activator is given in the printmaker manual.

If there is no lamp socket over your processing area, use an extension cord to suspend the safelight over the processing drum and/or trays. Keep the safelight at least 4 feet from your work area. A good safelight to use is the KODAK 2-Way Safelamp, available from photo dealers. This V-shaped safelight directs the light in two directions at once. You can screw it into the lamp socket of an extension cord or into a ceiling socket.

With a temporary darkroom it is important to consider ways of reducing the time and energy required to prepare the room and to clean it afterward. For instance, keeping all of your darkroom equipment in one or two boxes reduces both the time spent collecting equipment and the chance of misplacing something.

While the kitchen usually makes the best temporary darkroom, other rooms will serve. One possiblity is a bathroom. However, although it has running water and electricity, there may not be work surface to support trays and apparatus. You can make a work surface by placing a piece of plywood on the bathtub, but process-ing equipment will be uncomfortably low. Sometimes it's possible to set up a cardtable to hold your gear. Protect the tabletop from spilled solutions by covering it with a piece of plastic.

# PERMANENT INSTALLATIONS

A permanent color darkroom makes darkroom work much more convenient and saves a lot of setup time.

## Location

Where you decide to locate your darkroom will depend primarily on the space available and its accessibility to running water. However, you should also consider convenience, temperature, and humidity.

Although a room on the first or second floor is suitable for a darkroom, a dry basement is usually the ideal location. If your basement is damp, you can make it drier by using a dehumidifier, available from appliance and department stores. The ideal relative humidity for darkroom work is about 50 percent; the ideal temperature is between 70 and 75°F (18.5 and 21°C). It is usually easier to maintain this temperature in a basement than in any other part of the house. Furthermore, hot- and cold-water connections and electrical connections are generally available in a basement. Another advantage is the ease of making a basement lighttight. Most basements have only a few small windows that you can easily cover with a piece of fiberboard or dark cloth. One more advantage of the basement darkroom is that spilled solutions are likely to cause little damage. However, all spilled solutions should be wiped up immediately.

A damp basement without a dehumidifier is not a good location for a

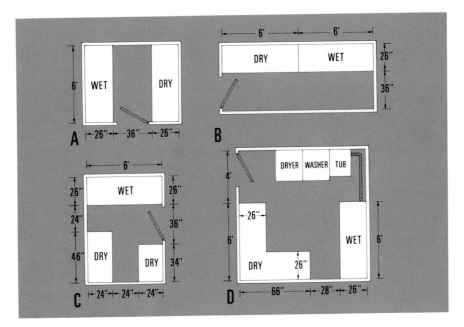

**Figure 2**   Plans for Permanent Darkrooms

*These basic layouts are designed for areas which are equipped with running water. If you choose a basement location, you can connect your darkroom-sink drainpipe to the existing drain and trap for the laundry tub. For plans A, B, or C, the darkroom can be built adjacent to the laundry area with the drainpipe passing through the wall to the nearby laundry tub. Plan D shows a way to solve the problem when the laundry tub and existing drain are located in a corner. The solution here is a combination laundry room/darkroom. (Note the routing of the darkroom-sink drainpipe.)*

permanent darkroom. Dampness causes mildew and rust on supplies and equipment. It also causes deterioration of films and papers, which can result in weak, mottled pictures. However, if you must use a damp location, store your chemicals, films, and printing papers where it is cool and dry, and take them to your darkroom only when you need them.

An attic is usually not satisfactory for a darkroom. Unless it is well insulated, an attic is likely to be too hot in the summer and too cold in the winter. Also, it is usually difficult and expensive to install plumbing in an attic.

## Size

The layouts for some recommended darkrooms, shown in Figure 2, are designed to provide the utmost convenience in the flow of work. The space used for a darkroom should be at least 6 x 7 feet (1.8 x 2.1 m).

You can close off the darkroom space from the rest of the area with partitions of wallboard. Partitions will help keep the darkroom free from dust and also prevent light from entering the area if someone opens the door to the basement. As a precaution, post a sign that reads **DARK-ROOM IN USE—KEEP OUT** on the darkroom door.

## Capability

You can use the darkroom floor plans illustrated in Figure 2 for both black-and-white and color work. They're designed so that you can process roll film or sheet film; make contact prints; and make enlargements up to 16 x 20 inches (40 x 50 cm) or larger, depending on the size of your processing equipment.

The darkroom layouts are arranged so that you can work efficiently with a minimum of wasted motion. They're also designed so that two or more people can divide the various operations and work together without interference. You can dry film and water-resistant prints with spring clothespins or film clips on a galvanized wire suspended between two walls in your darkroom.

## Arrangement

The darkroom units shown in Figure 2 consist of a dry bench (or benches) and a wet unit, each 26 inches (66 cm) wide. You can either have them built in a woodworking shop or assemble them yourself from ready-made kitchen cabinets.

Use the dry bench for enlarging and printing and for handling films, negatives, slides, and photographic paper. Since storage space for supplies and accessories is very important for work in this area, you'll want to have plenty of drawers and shelves. Also, it is convenient (but not essential) to have a lighttight drawer (dark drawer), illustrated in Figure 3, near your printing equipment. This will provide quick access to photographic paper when you are making prints and will eliminate the necessity of opening and closing the package of paper every time you need another sheet. When you have finished printing, you should return the unused photographic paper to its original package.

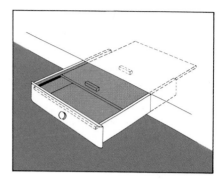

**Figure 3**   Dark Drawer

To make a drawer lighttight, install a sliding lid that fits in a groove around the top perimeter of the drawer. Paint the inside of the drawer and the lid flat black. Attach a small block of wood on the top of the lid and another one on the underside of the countertop. The blocks of wood will push the lid closed when you close the drawer.

You can use the space on top of the wet (or sink) unit for mixing chemicals and for all processing operations. Store your processing trays and chemical solutions beneath the unit. Shelves above each unit can provide storage space for bottles of stock solution, timers, thermometers, and other small equipment. Mount a towel holder near the sink to keep a towel for drying your hands.

You can locate the dry and wet units either on opposite sides of the darkroom with ample space between them or side by side with a splash guard separating them. With either arrangement, your equipment and materials will be protected against water and solutions splashed from the wet work area.

Suspend a safelight over each unit no less than 4 feet from the working surface. To provide safelight illumination for the dry bench, you can use a safelight such as a KODAK Darkroom Lamp or a KODAK 2-Way Safe-

lamp, with the proper safelight filter and bulb. For the processing area we suggest a larger safelight, like the KODAK Utility Safelight Lamp, Model D. Test your safelight as explained on page 4. Install double electrical outlets, properly grounded, over the units for plugging in your timer, enlarger, and other equipment.

Your sink should have a hot-and-cold mixing faucet. The nozzle should be at least 15 inches (38 cm) above the sink bottom, to provide space for filling bottles and rinsing your processing apparatus.

Because water and solutions will be spilled on the wet units, it should have a waterproof surface. An excellent material for this is sheet plastic, such as Formica, widely used for kitchen counters and tabletops. Sheet plastic has a hard surface which is resistant to most stains and corrosion. It's available in many attractive colors and easy to keep clean. You can purchase it in sheets and cement it to the top of the unit, or you can purchase it as a laminate, usually on chipboard, a form that's easier to install.

Other choices that you can use on top of the unit are linoleum or vinyl floor covering materials. You can extend these materials up the back wall to the shelf to protect the wall from splashes and eliminate the sharp, dust-catching corner at the rear. Treat the linoleum with a hard wax, rubbing it thoroughly into the surface to prevent penetration of spilled solutions. Vinyl is more expensive than linoleum but is more resistant to spills.

If you don't install a waterproof covering, the joints in the bench top must be tight enough to prevent solutions from dripping onto the shelf below. To protect the wood, coat the bench top with a chemical-resistant paint or lacquer.

If you want to build a deluxe dark-room, you can purchase a special sink for darkrooms, made from either stainless steel (Types 316 and 316L only) or a rigid, lightweight material like fiber glass.

To save money, many photohobbyists prefer to take the do-it-yourself approach and build their own sinks by constructing a plywood box and lining it with fiber-glass cloth and a few coats of resin for a strong, waterproof finish. The advantage in building your own sink, in addition to the cost savings, is that you can design it to the size and shape to fit your needs and darkroom-space requirements.

## Ventilation

Some processing operations are accompanied by chemical odors and fumes, high humidity from wash water, and heat from lamps, electric motors, or high-temperature processing solutions. For your health and comfort, you should introduce a plentiful supply of clean, fresh air into your darkroom—especially during the chemical-mixing and processing operations. Be sure to follow the safety recommendations given in the instructions packaged with the processing chemicals. Check the photo magazines in your local library for articles on building lighttight darkroom ventilators.

**Forbid smoking in your darkroom!** Not only does the ash cause dust of the finest sort, but the smoke particles coat enlarger lenses, negatives, slides, and printing filters, causing color shifts and focusing problems. During exposures, smoke in the air acts as a subtle diffuser, degrading tonal separation and color balance in the prints.

For complete information on designing and building your own darkroom, read KODAK Publication No. KW-14, *Building A Home Darkroom*, described on page 82.

9

# PROCESSING COLOR NEGATIVE FILM

*Here's a strip of color negatives after processing. Note that all the light parts of a subject are dark, all the dark parts are light, and the colors are the complementaries of those in the original scene.*

## WHAT YOU'LL NEED

To produce high-quality negatives from KODACOLOR VR Films, you'll need the following equipment:

- Film-developing tank with spiral reel
- Photo thermometer
- Darkroom timer or clock
- KODAK HOBBY-PAC™ Color Negative Film Kit
- 4 500 mL (16.9 fluidounces) bottles for storing chemicals
- 4 500 mL (16.9 fluidounces) mixing containers
- Rubber gloves
- 1 large, deep tray
- Film clips or spring clothespins
- Negative-filing envelopes
- Scissors
- Soft sponge or KODAK Photo Chamois

Make sure that the processing tank you use is recommended for color film and the size of your film. See your photo dealer or the film-tank instructions. Tanks that use spiral reels are recommended for processing color film. Don't process roll film in trays, because the film emulsion can become scratched.

The photo thermometer must be a sensitive, accurate one for the critical temperatures required in color processing. The KODAK Process Thermometer, Type 3, is recommended for this purpose. Your darkroom timer or clock must have a sweep-second hand.

The KODAK HOBBY-PAC Color Negative Film Kit, sold by photo dealers, includes all the chemicals you need and full instructions for their use. The kit contains 2 complete sets of developer and 1 set of the other solutions because you can process twice as much film in the other solutions as you can in the developer.

To store your solutions, use 500 mL bottles with labels. Use a waterproof marking pen to write the solution name and date it was mixed on the appropriate label or directly on the bottle. Each bottle should have a tight-fitting, reusable cap to protect its contents from prolonged contact with the outside air.

It's very important that you process your film in the color process

recommended for it. Processing your film in the wrong chemicals can ruin your film and contaminate the processing solutions.

**WARNING:** Wear clean rubber gloves to avoid skin irritation when mixing or pouring solutions, processing film or prints, and cleaning the darkroom. Wash the gloves before you take them off. **READ THE LABELS.** The precautionary and first aid statements on the chemical containers and mixing instructions will answer many of the questions about photochemical hazards. For more information about the physical effects resulting from contact with Kodak chemicals, write to Eastman Kodak Company, Health and Safety Laboratory, Kodak Park, Rochester, NY 14650.

**KODAK MAINTAINS 24-HOUR POISON INFORMATION.**

If emergency information is needed, telephone:

(716) 722-5151

## BASIC PROCEDURE

Processing color negative film is easy, but for best results you do have to follow *carefully* the instructions that come with the chemicals. It's important that you adjust the temperature of the solutions so that they're within the recommended range. Timing each processing step accurately and following the recommended procedure for agitation of the film tank are equally important for consistently good results. Avoid contaminating each chemical solution with the other solutions in the process. Always follow the order of the processing steps listed in the chemical instructions.

Before you process your film, mix the chemicals according to the chemical instructions. Several of the chemi-

cals have more than one part, such as parts A, B, and C. *Do not mix these parts together at the same time.* Mix the parts one at a time in the solution according to the specific instructions for each chemical.

Store the chemical solutions in tightly closed bottles. Since the useful life of color-processing solutions is only a few weeks (see page 15), mix the solutions just before you are ready to use them.

When you're ready to process your film, adjust the temperature of the solutions by placing them, in their storage bottles, into a tray of running water at the proper temperature. Check the temperature of each solution with your thermometer, carefully rinsing the thermometer in clean water after checking each solution. The temperature of the developer, which is the most critical, should be adjusted last, just before you're ready to start processing. Since you use the developer first in the process, maintaining the proper temperature is not too difficult.

Loading Kodak color film into the developing tank requires *TOTAL DARKNESS.* Rip the Exposed sticker on **roll film** and carefully separate the film from the paper backing. Be careful not to cinch or scratch the film. The film is attached to the paper with a strip of tape at the end near the core of the film spool.

To open **110 cartridges**, use both hands to grasp the two cylindrical chambers with the label facing you. Place your thumbs on the label and bend the chambers back to break the cartridge. Then pull the film, together with its backing paper, from the take-up chamber in a direction so that the paper rubs against the inner surface of the cartridge back. This precaution minimizes the likelihood of scratching the film emulsion. If the end of the backing paper (trailer) has been wound into the take-up cham-

11

*These two pictures show the versatility of KODACOLOR VR 1000 Film, which lets you use a high shutter speed to freeze the action when the light is less than ideal.*

*300 mm lens, f/2.8, 1/1000 sec*

*200 mm lens, f/2, 1/1000 sec*

**Above**

*When loading a roll of film into a tank, handle it by the edges, and roll it onto the reel or apron according to the tank instructions. Remember that total darkness is a must during this operation. If you are unfamiliar with loading film into a tank, you may want to practice first with the lights on, using a roll of outdated, scrap film.*

## PROCESSING— STEP BY STEP

This process requires 6 steps that take 24 1/4 minutes, not including the time it takes for your film to dry. The temperature of the developer for the first step must be 100 ± ¹/₄°F (37.8 ± ¹/₄°C). The other solutions and the wash water should be within a range of 75 to 105°F (24 to 40.5°C). The processing steps and the time in each solution are summarized in the chart on page 15.

### Maintain Proper Temperatures

You must maintain the developer at 100°F. Should the developer temperature drift above or below 100°F during the developing step, negatives could turn out too dark or too light.

*Keep your processing tank in the water bath between agitation cycles.*

ber, you will have to pry open the chamber (after breaking the cartridge) to retrieve the film.

Break open **126 cartridges** by using both hands to bend the two cylindrical chambers toward the label. Remove the film from the larger chamber by separating the plastic sections surrounding the spool. The film is attached to the paper backing in the same way as roll film.

To open **135 magazines**, hold the magazine with the long end of the spool down, and use a lid lifter or a hook-type bottle opener to remove the upper end cap from the magazine. The film is attached to the magazine spool with a strip of tape; separate the film from the spool. Load the film-tank reel according to the film-tank instructions.

Because of the high agitation requirements for processing and drying, the use of this kit is not currently recommended for processing the KODACOLOR VR Disc Film.

To control the temperature of the solutions, put water into a tray to a depth so that it is at least equal to the solution depth in the processing tank. The temperature of this water bath should be 100.5°F (38°C) for a room temperature of 75°F. You can maintain processing solutions and the empty processing tank at a room temperature of 75°F before processing, but be sure to bring them to 100°F just prior to processing. To

bring them up to temperature, place them into the water bath for about 10 minutes. Stir the developer with the thermometer and read the temperature frequently. After processing begins, keep the processing tank in the water bath when you aren't agitating it.

*Agitation means turning the tank upside down and back, once each second.*

## Watch Your Timing

Start the timer immediately when you've poured the developer solution into the tank. The time of each step includes the drain time (usually about 10 seconds). This will vary, depending on the type of tank you have and whether the cover is on or off. In each case, start draining in time to end the processing step—and start the next one—on schedule.

*Each "S," either backward or forward, is one agitation cycle.*

## Handling and Agitation

Load the reels and tanks in total darkness. The film requires total darkness during the development and bleach steps.

Agitation is critical, especially in the developer, and must be done with care and precision. You can agitate your film either by inverting the processing tank, rotating the tank, or rotating the reel—which method you select will depend on the design of your tank. Tanks that can be inverted are recommended.

*One complete turn (360°) is one agitation cycle.*

## Drying

Remove the film from the reel and hang it up to dry for at least 10 minutes at 75 to 110°F (24 to 43.5°C) in a dust-free atmosphere with adequate air circulation. Attach a clothespin or film clip to the lower end of the roll to prevent curling during drying.

To avoid spots on the film, gently wipe the base side only of the wet film with a soft sponge or KODAK Photo Chamois moistened with stabilizer solution.

## Processing KODACOLOR VR Films using the KODAK HOBBY-PAC Color Negative Film Kit

| Solution or Procedure | Time In Min* | Minutes Used at End of Step | Minutes Remaining at End of Step | Temperature | Agitation (seconds) | | |
|---|---|---|---|---|---|---|---|
| | | | | | Initial† | Rest | Agitate |
| Developer | 3¼ | 3¼ | 21 | 100 ± ¼°F (37.8 ± 0.15°C) | 30 | 13 | 2 |
| Bleach | 6½ | 9¾ | 14½ | 75 to 105°F (24 to 41°C) | 30 | 25 | 5 |

**Remaining steps can be done in normal room illumination.**

| Solution or Procedure | Time In Min* | Minutes Used at End of Step | Minutes Remaining at End of Step | Temperature | Agitation (seconds) | | |
|---|---|---|---|---|---|---|---|
| Wash‡ (Running water) | 3¼ | 13 | 11¼ | | | | |
| Fixer | 6½ | 19½ | 4¾ | 75 to 105°F (24 to 41°C) | 30 | 25 | 5 |
| Wash‡ (Running water) | 3¼ | 22¾ | 1½ | | | | |
| Stabilizer | 1½ | 24¼ | 0 | | 30 | | |
| Dry | Film removed from reels; temperature between 75 to 110°F (24 to 43°C) for 10 to 20 minutes. If a drying cabinet is used, the air should be filtered. A sponge moistened with stabilizer can be used to carefully wipe away water spots on the base side of the film. | | | | | | |

*Includes 10-second drain time in each step.

†Rap the bottom of the tank firmly on the sink or table to dislodge any air bubbles from the film surface. Be sure you have read the agitation recommendations elsewhere in these instructions.

‡Use fresh water changes throughout the wash cycles. Fill the processing tank as rapidly as possible from a running water supply for about 4 seconds. When full, agitate vigorously for about 2 seconds and drain for about 10 seconds. Repeat this full wash cycle. If desired, use a running water inflow-overflow wash with the cover removed from the tank.

## STORAGE OF SOLUTIONS

Store mixed solutions in full, tightly capped containers at normal room temperature (40°F to 85°F [4.5°C to 29.5°C]). With proper storage, working strength solutions will last five weeks. Solutions stored in partially full bottles have a shorter useful storage life. Mark the mixing date on the storage container.

## CAPACITY OF SOLUTIONS

For consistent and satisfactory photographic quality, use fresh solutions. The instructions supplied with the kit contain data on the number of rolls that you can process per 500 mL of developer before it becomes exhausted. For example, the two 500 mL solutions of developer can process 6–8 rolls of KODACOLOR VR Film, size 135-36, with appropriate developing-time increases. Check the recommendations in the instructions accompanying the kit before processing any film in quantity.

# PROCESSING COLOR SLIDE FILM

## WHAT YOU'LL NEED

To process any roll or 135 film designed for process E-6, such as KODAK EKTACHROME 100, 160, 200, 400 and P800/1600 (Daylight) Films, you can use many of the same hardware items required for producing color negatives mentioned on page 10. On the other hand, the chemicals required are not the same. Here's the complete list of what you'll need:

- 500 mL (16.9 fluidounces) tank with spiral reel
- Photo thermometer
- Darkroom timer or clock
- KODAK HOBBY-PAC™ Color Slide Kit
- 4 500 mL (16.9 fluidounces) bottles for storing chemicals
- 3 500 mL (16.9 fluidounces) mixing containers
- Rubber gloves
- 1 large, deep tray
- Film clips or spring clothespins
- Scissors
- Soft sponge or film squeegee

The new KODAK HOBBY-PAC Color Slide Kit contains five liquid-filled packets and one bottle of liquid to make four solutions for producing transparencies from KODAK EKTACHROME Films (for Process E-6). Complete instructions for their use are contained with the kit.

You can't process KODACHROME Films successfully yourself. The complex process requires large scale commercial equipment.

*A strip of KODAK EKTACHROME 100 Film (Daylight) after processing.*

**WARNING:** Please take notice of the warnings that appear on the individual units of the kit. In case of contact of solutions or solid chemicals (especially developers or developing agents) with your skin, wash at once with an acidic hand cleaner* and rinse with plenty of water. Wear clean rubber gloves as described under **WARNING** on page 11.

## BASIC PROCEDURE

Procedures for opening film rolls and cartridges, loading the film tank, and bringing solutions to the proper temperature are the same as those outlined for the HOBBY-PAC Color Negative Film kit. (**BASIC PROCEDURE** for color negative film, pages 11 and 13).

KODAK HOBBY-PAC Color Slide Kit involves seven steps. For best results, your EKTACHROME Film should be processed between 96°F (35.5°C) and 110°F (43.5°C), but acceptable results can be achieved as low as 70°F (21°C). See the table on page 19 for processing times and temperatures.

### Maintain Proper Temperatures

To help you control the temperature of the processing solutions, you can follow the procedure described on page 13.

### Watch Your Timing

The time for each processing step includes the time required to drain the tank—usually about 10 seconds, depending on the construction of the tank and on the cover being on or off. In each case, start draining in time to end the processing step—and start the next one—on schedule.

*Such as PHISODERM, available at drugstores.

### Handling and Agitation

Become familiar with the proper technique for loading your tank reel. Unless you follow the instructions (supplied by the tank and reel manufacturer), physical abrasions on the film or uneven development can result. Load the tank in complete darkness, and attach the cover securely before turning on any lights.

For proper agitation, follow the suggestions on page 14 for processing color negative film.

## PROCESSING— STEP BY STEP

1. First Developer
   The first developer is the most critical step. Prior to this step, adjust all three processing solutions and the film tank to the desired processing temperature. Pour in the first developer and start timing, tapping, and agitation as directed. Initial and subsequent agitation are required. Refer to the TIME/TEMPERATURE TABLE to determine the appropriate first developer time. Remember that the development time includes the drain time.

2. Wash
   Fill the tank with water at about the same temperature as the first developer. Agitate, drain, and repeat until the film has at least four complete rinses—about 1 to 3 minutes. Use running water if available. The rinse water will be very pale yellow after the last rinse.

The following steps may be done in room light.

3. Color Developer
   Consult the TIME/TEMPERATURE TABLE to determine the appropriate processing time for your temperature. Use initial and subsequent agitation.

## Summary of Steps

For your convenience, fill in this table with your most commonly used times and temperature.

| SOLUTION | TEMPERATURE | AGITATION* | TIME (minutes) | TOTAL TIME (minutes) |
|---|---|---|---|---|
| FIRST DEVELOPER | — | Every 30 sec | — | — |
| WASH | 70°–110°F (21°–43.5°C) | 4 Complete rinses | 1–3 | — |
| COLOR REPLENISHER | — | Every 30 sec | — | — |
| WASH | 70°–110°F (21°–43.5°C) | 4 Complete rinses | 1–3 | — |
| BLEACH-FIX | 70°–110°F (21°–43.5°C) | Every 30 sec | 10 | — |
| FINAL WASH | 70°–110°F (21°–43.5°C) | 6 Complete rinses | 4 | — |
| STABILIZER | 70°–110°F (21°–43.5°C) | Initial only | 1 | — |

*intitial and subsequent agitation procedures for invertible and noninvertible tanks are found in the instructions contained with the kit.

4. Wash
   Repeat step 2. The rinse water should be very pale blue after the last rinse.

5. Bleach-Fix
   Process the film in the bleach-fix for ten minutes at any temperature between 70°F (21°C) and 110°F (43.5°C). Longer time will not hurt the film. Use initial and subsequent agitation.

6. Wash
   Wash the film continuously for at least 4 minutes or fill and dump the tank at least six times in 4 minutes. If you use running water, tap the tank every 30 seconds to dislodge air bubbles. The lid to the processing tank may be removed for this step to facilitate washing. The final rinse should appear clear and colorless.

7. Stabilizer
   Process the film in the stabilizer for at least 1 minute at any temperature between 70°F (21°C) and 110°F (43.5°C). Use only initial agitation.

8. Dry
   Remove the film from the reel and hang it up to dry in a dust-free environment. A weighted film clip or clothespin on the bottom end of the strip will keep it hanging straight. Immediately after hanging up the film, remove the excess surface moisture from both sides of the film with a film squeegee or soft viscous sponge saturated with water or dilute wetting agent. Be careful not to scratch the soft emulsion. Failure to remove the water droplets may leave waterspots on the film. If heat is used to dry the film, do not let the temperature exceed 140°F (60°C) or the film will curl excessively. The emulsion side of the film will be opalescent when wet. Color balance and density should be evaluated after the film has dried.

18

## Time/Temperature Table for Normal Processing KODAK EKTACHROME Films Using the KODAK HOBBY-PAC Color Slide Kit

| TEMPERATURE | | FIRST DEVELOPER TIME (minutes) | | |
| --- | --- | --- | --- | --- |
| | | Capacity of Solutions* | | |
| °F | °C° | 1st Third | 2nd Third | 3rd Third |
| 70 | 21 | **26** | 27 | 28 |
| 72 | 22 | **24** | 25 | 26 |
| 74 | 23.5 | **21½** | 22½ | 23 |
| 76 | 24.5 | **19½** | 20 | 21 |
| 78 | 25.5 | **18** | 18½ | 19½ |
| 80 | 26.5 | **16½** | 17 | 18 |
| 82 | 28 | **15** | 15½ | 16 |
| 84 | 29 | **13½** | 14 | 14½ |
| 86 | 30 | **12½** | 13 | 13½ |
| 88 | 31 | **11½** | 12 | 12½ |
| 90 | 32 | **10½** | 11 | 11¼ |
| 92 | 33.5 | **9½** | 10 | 10¼ |
| 94 | 34.5 | **8½** | 8¾ | 9¼ |
| 96 | 35.5 | **7¾** | 8 | 8¼ |
| 98 | 36.5 | **7** | 7¼ | 7½ |
| 100 | 38 | **6½** | 6¾ | 7 |
| 102 | 39 | **5¾** | 6 | 6¼ |
| 104 | 40 | **5¼** | 5½ | 5¾ |
| 106 | 41 | **4¾** | 5 | 5¼ |
| 108 | 42 | **4½** | 4¾ | 4¾ |
| 110 | 43.5 | **4** | 4¼ | 4¼ |

| TEMPERATURE | | COLOR DEVELOPER TIME (minutes) |
| --- | --- | --- |
| °F | °C | |
| 70 | 21 | **9** |
| 75 | 24 | **8½** |
| 80 | 26.5 | **8** |
| 85 | 29.5 | **7½** |
| 90 | 32 | **7** |
| 95 | 35 | **6½** |
| 100 | 38 | **6** |
| 105 | 40.5 | **5½** |
| 110 | 43.5 | **5** |

*See CAPACITY OF SOLUTIONS, page 20.

## STORAGE OF SOLUTIONS

Store mixed solutions, unused or partially used, in full, tightly capped bottles at normal room temperatures. For best results, do not use solutions which have been stored longer than a few weeks. Instructions supplied with the kit list in detail the maximum storage times for used and unused solutions.

## CAPACITY OF SOLUTIONS

For any given film size, each 500 mL (16.9 fluidounces) of first developer, color developer, and bleach-fix will process the number of rolls listed below.

Since oxidation and solution loss occur every time a roll of film is processed, this kit should not be used for more than six processing runs, regardless of the number of rolls processed.

In order to compensate for exhaustion of the first developer, the first developer time must be increased after film has been processed. After one-third of the recommended solutions capacity has been reached (for example, 2 rolls of size 135-36 film), increase the first developer time by another 4 percent. These times are summarized in the TIME/TEMPERATURE TABLES.

## PUSH-PULL PROCESSING

The effective speed of EKTACHROME Films may be increased by as much as three stops or decreased as much as two stops with this processing kit. This results in some loss in quality compared with normal exposure and processing, but it allows you to obtain photographs that would otherwise be unsuitable. The increased speed is very helpful under dim lighting conditions—in existing light, for example. It's also helpful when you want to use high shutter speeds and small lens openings. However, push processing (increasing the effective film speed by overdevelopment) results in lower D-max (blacks are lighter), less film latitude, and an increase in grain. Pushing two stops shows these characteristics more than pushing one stop and pushing three stops shows them even more. Use the push-three-stops recommendation only when necessary. When pushing or pulling EKTACHROME Film, the first developer time (and color developer time at push-three-stops) must be increased and/or decreased, respectively.

Use the chart on page 23 to determine the camera meter setting to use for push-pull processing.

| Film Size | 110-20 | 126 | 127 | 135-20 | 135-36 | 120 |
|---|---|---|---|---|---|---|
| Rolls/500 mL | 27 | 12 | 12 | 8 | 6 | 6 |

*KODAK EKTACHROME P800/1600 Profes-*
*sional Film (Daylight), exposed at an expo-*
*sure index of 800 with processing time*
*modified.*

21

# Time/Temperature Tables for Push-Pull Processing KODAK EKTACHROME Films

FIRST DEVELOPER TIME (min)*

| TEMPERATURE | | Pull 2 Stops | | | Pull 1 Stop | | | Push 1 Stop | | | Push 2 Stops | | | Push 3 Stops | | |
|---|---|---|---|---|---|---|---|---|---|---|---|---|---|---|---|---|
| °F | °C | 1st Third | 2nd Third | 3rd Third | 1st Third | 2nd Third | 3rd Third | 1st Third | 2nd Third | 3rd Third | 1st Third | 2nd Third | 3rd Third | 1st Third | 2nd Third | 3rd Third |
| 70 | 21 | 17½ | 18 | 19 | 21 | 22 | 22½ | 42 | 43½ | 45½ | 52 | 54 | 56 | 65 | 67½ | 70 |
| 72 | 22 | 16 | 16½ | 17½ | 19½ | 20 | 21 | 38½ | 40 | 41½ | 47½ | 49½ | 51½ | 60 | 62½ | 65 |
| 74 | 23.5 | 14½ | 15 | 15½ | 17½ | 18 | 19 | 35 | 36½ | 38 | 43½ | 45 | 47 | 54½ | 56½ | 59 |
| 76 | 24.5 | 13 | 13½ | 14 | 16 | 16½ | 17½ | 32 | 33½ | 34½ | 39½ | 41 | 42½ | 49½ | 51½ | 53½ |
| 78 | 25.5 | 12 | 12½ | 13 | 14½ | 15 | 15½ | 29 | 30 | 31½ | 36 | 37½ | 39 | 45 | 47 | 48½ |
| 80 | 26.5 | 11 | 11½ | 12 | 13½ | 14 | 14½ | 26½ | 27½ | 28½ | 33 | 34½ | 35½ | 41 | 42½ | 44½ |
| 82 | 28 | 10 | 10½ | 10¾ | 12 | 12½ | 13 | 24 | 25 | 26 | 30 | 31 | 31½ | 37½ | 39 | 40½ |
| 84 | 29 | 9 | 9¼ | 9¾ | 11 | 11½ | 12 | 22 | 23 | 24 | 27 | 28 | 29 | 34 | 35½ | 36½ |
| 86 | 30 | 8¼ | 8½ | 9 | 10 | 10½ | 10¾ | 20 | 21 | 21½ | 25 | 26 | 27 | 31 | 32 | 33½ |
| 88 | 31 | 7½ | 7¾ | 8 | 9 | 9½ | 9¾ | 18 | 18½ | 19½ | 22½ | 23½ | 24½ | 28 | 29 | 30 |
| 90 | 32 | 6¾ | 7 | 7¼ | 8¼ | 8½ | 9 | 16½ | 17 | 18 | 20½ | 21½ | 22 | 25½ | 26½ | 27½ |
| 92 | 33.5 | 6¼ | 6½ | 6¾ | 7½ | 7¾ | 8 | 15 | 15½ | 16 | 19 | 20 | 20½ | 23½ | 24½ | 25½ |
| 94 | 34.5 | 5¾ | 6 | 6¼ | 6¾ | 7 | 7¼ | 13½ | 14 | 14½ | 17 | 17½ | 18½ | 21½ | 22½ | 23 |
| 96 | 35.5 | 5¼ | 5½ | 5¾ | 6¼ | 6½ | 6¾ | 12½ | 13 | 13½ | 15½ | 16 | 17 | 19½ | 20 | 21 |
| 98 | 36.5 | 4¾ | 5 | 5¼ | 5¾ | 6 | 6¼ | 11½ | 12 | 12½ | 14 | 14½ | 15 | 17½ | 18 | 19 |
| 100 | 38 | 4¼ | 4½ | 4½ | 5¼ | 5½ | 5¾ | 10½ | 11 | 11¼ | 13 | 13½ | 14 | 16 | 16½ | 17½ |
| 102 | 39 | 3¾ | 4 | 4 | 4¾ | 5 | 5¼ | 9½ | 10 | 10¼ | 12 | 12½ | 13 | 14½ | 15 | 15½ |
| 104 | 40 | 3½ | 3¾ | 4 | 4¼ | 4½ | 4¾ | 8½ | 8¾ | 9¼ | 11 | 11½ | 12 | 13 | 13½ | 14 |
| 106 | 41 | 3¼ | 3½ | 3½ | 4 | 4¼ | 4½ | 7¾ | 8 | 8¼ | 9¾ | 10¼ | 10½ | 12 | 12½ | 13 |
| 108 | 42 | 2¾ | 2¾ | 3 | 3½ | 3¾ | 4 | 7 | 7¼ | 7½ | 9 | 9¼ | 9¾ | 11 | 11½ | 12 |
| 110 | 43.5 | 2½ | 2½ | 2¾ | 3¼ | 3½ | 3½ | 6½ | 6¾ | 7 | 8 | 8¼ | 8½ | 10 | 10½ | 10¾ |

*See CAPACITY OF SOLUTIONS, page 20.

| Temperature | | Color Developer Time (minutes) for Push-Pull Processing | | | | |
|---|---|---|---|---|---|---|
| °F | °C | Pull 2 Stops | Pull 1 Stop | Push 1 Stop | Push 2 Stops | Push 3 Stops** |
| 70 | 21 | 9 | 9 | 9 | 9 | 26 |
| 75 | 24 | 8½ | 8½ | 8½ | 8½ | 24 |
| 80 | 26.5 | 8 | 8 | 8 | 8 | 22 |
| 85 | 29.5 | 7½ | 7½ | 7½ | 7½ | 20 |
| 90 | 32 | 7 | 7 | 7 | 7 | 18 |
| 95 | 35 | 6½ | 6½ | 6½ | 6½ | 16 |
| 100 | 38 | 6 | 6 | 6 | 6 | 14 |
| 105 | 40.5 | 5½ | 5½ | 5½ | 5½ | 12 |
| 110 | 43.5 | 5 | 5 | 5 | 5 | 10 |

**Diluted color developer only. See instructions supplied with the kit.

## Camera Meter Settings for Push-Pull Processing

| Film | Pull 2 | Pull 1 | Normal | Push 1 | Push 2 | Push 3 |
|---|---|---|---|---|---|---|
| EKTACHROME 100 | 25 | 50 | 100 | 200 | 400 | 800 |
| EKTACHROME 160 | 40 | 80 | 160 | 320 | 640 | 1280 |
| EKTACHROME 200 | 50 | 100 | 200 | 400 | 800 | 1600 |
| EKTACHROME 400 | 100 | 200 | 400 | 800 | 1600 | 3200 |
| EKTACHROME P800/1600* | 100 | 200 | 400 | 800 | 1600 | 3200 |

*This film is designed for exposing and push processing to speeds of either EI 800 or EI 1600. You can also expose and process the film to EI 3200 but with some loss in quality. Exposing and processing the film to EI 400 requires the use of a KODAK Color Compensating Filter CC10Y over the camera lens.

# PRINTING COLOR NEGATIVES USING *KODAK EKTACOLOR* AND *KODAK PANALURE* PAPERS

Making your own color prints from color negatives on EKTACOLOR Paper provides a whole new area of photography for you to enjoy. You can make prints nearly any size you want—from small ones to big enlargements. You can crop pictures for the composition that's most pleasing to you. You can control the lightness or darkness of the print, as well as the color balance, and you can experiment with control techniques to achieve just the effect you're looking for. The possibilities for creating

beautiful color prints are as great as your own imagination.

Printing color negatives is more difficult than processing color film, but it's often more rewarding, too. By carefully following the instruction sheets for the chemicals and paper and the procedures on the following pages, you should have no trouble in achieving excellent results. Making black-and-white prints on PANALURE Paper from color negatives is discussed on page 44.

## COLOR RELATIONSHIPS

Before going ahead into this fascinating subject of color printing, let's make sure we understand some basic photographic color and visual relationships.

1. White light (sunlight or the light from an enlarger lamp) is composed of three primary colors—red, green, and blue. These colors are known as additive primary colors since, when added together in approximately equal amounts, they produce white light.

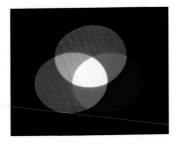

*When red, green, and blue light are combined, white light is produced.*

2. Color negative film has separate light-sensitive layers to correspond with each of these three additive primary colors. Images recorded on these layers appear as complementary (opposite) colors.

- A red subject will record on the red-sensitive layer as cyan (blue-green).

- A green subject will record on the green-sensitive layer as magenta (blue-red).

- A blue subject will record on the blue-sensitive layer as yellow.

3. Cyan, magenta, and yellow are called subtractive primary colors since each one, when added to its complementary color, can absorb all color to produce black or shades of gray.

4. The interaction of the additive primary colors beamed from an enlarger lamp and the subtractive primary colors in the filters and color-negative layers form the controls necessary in color printing.

## UNDERSTANDING COLOR NEGATIVES

You can't really tell what your pictures will look like until you see color prints made from your color negatives. All the tones and colors of the original scene are reversed in the negative: light tones are recorded as dark; dark tones are recorded as light; and the colors are the complements of colors you saw in the scene.

*Color Negative*

Print made on KODAK EKTACOLOR PLUS Paper.

In addition, Kodak color negative films have a built-in masking layer that helps improve the quality of prints made from them. This mask gives the negatives an overall color cast of light orange-tan. All the color relationships are properly reproduced when you print the image from your negatives onto color photographic paper.

26

# WHAT YOU'LL NEED

## Enlarging Equipment

To expose color prints, you'll need the following items:

- Enlarger*
- Color printing filters (CC if used between the enlarger lens and the paper; CP if used between the lamp and the negative)
- Enlarging easel*
- Voltage regulator (optional)
- Safelight
- Camel's-hair brush*
- Enlarger timer*

You can make color enlargements with almost any enlarger equipped with a tungsten or tungsten-halogen lamp and a heat-absorbing glass in the lamphouse.

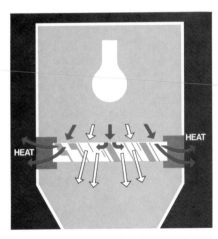

*Use a heat-absorbing glass in the enlarger lamphouse to protect filters from fading. If you don't have one of these inexpensive items in your enlarger, see your photo dealer.*

No light other than that passing through the negative should reach the enlarger lens. If the image area of your negative doesn't quite fill the opening in the negative carrier, mask the negative with black paper or black paper tape. If the enlarger head leaks light, cover it with aluminum foil or other nonflammable material in order to prevent fogging of your color paper.

*This additive (tricolor) enlarger has dichroic filters built into its lamphouse so users can simply dial the filter pack they want.*

Be sure your enlarger is equipped with a lens of a focal length compatible with your film size. The focal length of a normal enlarging lens should be approximately equal to the diagonal measurement of the negative to be enlarged. For example, to enlarge 135-size film successfully, you need an enlarger lens with a 50 mm or higher focal length.

---

*These items are the same as those you need for making black-and-white prints.

If the enlarger you use for color printing has provisions for putting the required color filters between the lamp and the negative, so much the better. This isn't absolutely necessary but simpler and less expensive, as you'll see shortly.

Another item that is very helpful, although not a necessity, is a voltage regulator. A voltage regulator in the power supply for the enlarger prevents undesirable changes in light output and color quality of the enlarger lamp. If you don't use a voltage regulator, try to avoid exposing your color prints during times when the line voltage is likely to fluctuate, e.g., before mealtimes when many electric appliances are in use.

*The KODAK Adjustable Safelight Lamp, Model B, holds a 5 1/2-inch (140 mm) circular filter. With its double-swivel shank and bracket, it can be attached to a wall, shelf, or bench and be swung or tipped as needed.*

*This enlarger has a filter drawer between the lamphouse and the negative compartment to accept acetate color printing (CP) filters.*

## Papers

KODAK EKTACOLOR 74 RC Paper is a water-resistant paper recommended for making color enlargements from color negatives of all normal-contrast subjects. KODAK EKTACOLOR PLUS Paper, besides having water-resistant surfaces, has higher contrast and maximum density characteristics which make it more suitable for application where additional contrast and color saturation are desirable.

For consistent quality, protect your paper from heat and humidity. Prolonged storage at room temperature will seriously alter the color balance. When you're not using your paper, store it in a refrigerator at 55°F (13°C) or lower. Fold the end of the foil-lined envelope over twice, to help seal out moisture. To prevent moisture condensation on the cold paper, remove it from the refrigerator at least 2 hours before use. Don't open the package until you're ready to begin printing.

When exposing a sheet of EKTACOLOR Paper, the emulsion side

should face the enlarger light (emulsion side up). Under safelight illumination, you can determine the darker side of the paper which is coated with emulsion. The emulsion before processing is gray, while the base side is always white. Depending on how bright your normal room lights were, you may have to be in the dim safelight environment a minute or two before your eyes adjust well enough to make this visual examination of the paper.

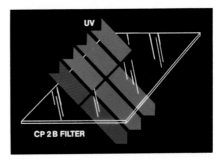

*Use a UV filter in your enlarger lamphouse to prevent ultraviolet-radiation exposure on the color paper.*

**Safelight.** You can handle EKTACOLOR Papers for no longer than 3 minutes under a safelight lamp equipped with a KODAK 13 Safelight Filter (amber), with a 7½-watt bulb. The paper must be at least 4 feet from the safelight. (For information on making a simple safelight test, see page 4.)

**Sizes and surfaces.** EKTACOLOR 74 RC and EKTACOLOR PLUS Papers are available in 8 x 10-inch and larger sheet sizes. You can select from three different paper surfaces—E (fine-grained lustre), F (smooth glossy), and N (smooth lustre).

## Color Filters

In color enlarging, the three emulsion layers in the paper must be correctly exposed from the three color records in the negative. The exposure of these three layers is controlled both by exposure time and by the color of the light reaching the paper. Since the color of the light is controlled by placing color filters in the enlarger light beam, you need a set of color filters. Depending on your enlarger design, you may also need a filter to absorb ultraviolet radiation, i.e., a KODAK WRATTEN Gelatin Filter No. 2B or KODAK Color Printing Filter CP2B (Acetate). Enlargers having a built-in additive (tricolor) filtration system do not require a UV absorber. Their dichroic filters intercept all the

light in the lamphouse, efficiently preventing UV radiation exposure on photographic paper.

There are three kinds of color filters for color printing. The kind you use depends on where the filters are placed—between the lamp and the negative (dichroic or acetate filters) or between the enlarger lens and the paper (gelatin filters).

It's best, although not absolutely necessary, for the enlarger to have a provision for putting the filters into the lamphouse between the lamp and the negative. This is better than putting the filters into the image-forming light below the negative because there's no limitation to the number of filters you can use above the negative. Some enlargers have dichroic color-printing filters by simply adjusting the filter controls. If your enlarger doesn't have the filters built in but accepts filters above the negative, you'll need several color printing filters. KODAK Color Printing Filters (Acetate) are identified by the letters CP. You should not use CP filters below the negative because they would adversely affect definition in the print.

CC filters go below the lens.

CP filters go into the lamphouse between the lamp and the negative.

Dichroic filters are built into the lamphouse.

KODAK Color Compensating Filters go below the enlarger lens and are identified by the letters CC. They are made of gelatin and cost more than CP Filters of the same size. Since you can use them in the image-forming beam of the enlarger, be especially careful to handle them only by the edge to keep them clean and free of dust.

The numbers and letters used to identify filters tell you the type, density, and color. For example, in the case of a CP20Y Filter, the CP stands for Color Printing, 20 means the density is 0.20 (to blue light), and Y means the color is yellow.

**The filters you'll need.** If your enlarger accepts filters *above* the negative, you'll need a selection of color-printing (acetate) filters. With the filters below, you should be able to make any combination necessary for controlling color balance:

| CP2B (always used) | | |
|---|---|---|
| CP05M | CP05Y | CP40R |
| CP10M | CP10Y | CP80R |
| CP20M | CP20Y | |
| | CP40Y | |
| | CP80Y | |

If your enlarger is constructed so that you must place the filters *below* the lens, you'll need the following color compensating (gelatin) filters:

| Gelatin No. 2B or CP2B (Acetate) installed permanently above the negative | | |
|---|---|---|
| CC05R | CC05M | CC05Y |
| CC10R | CC10M | CC10Y |
| CC20R | CC20M | CC20Y |
| CC30R | CC30M | CC30Y |
| CC40R | CC40M | CC40Y |
| CC50R | CC50M | CC50Y |

You'll need all of these CC filters to obtain the necessary filtration with three or fewer filters in the pack. You should never use more than three filters together below the lens. On the other hand, since you can use any number of filters above the negative, you can achieve all the colors and densities required by using combinations of the CP filters in the first list.

Occasionally, you may need cyan filtration. If so, use either the series CP-2 or CC-2 filters.

## Chemicals and Processing Equipment

To process EKTACOLOR Papers, you'll need the following items:

- Tube-type processor
- Photo thermometer
- Darkroom timer or clock
- KODAK HOBBY-PAC™ Color Print Kit
- KODAK EKTACOLOR 74 RC or PLUS Paper
- 3 bottles for storing solutions (large enough to hold 780 mL [26.4 fl oz])
- 3 mixing containers (large enough to hold 780 mL [26.4 fl oz])
- Darkroom graduate
- Stirring paddle
- Rubber gloves
- Scissors
- Large, deep tray
- Soft sponge or squeegee

*A dial thermometer connected to the end of a hot-and-cold water faucet simplifies temperature control. The thermometer constantly meters the temperature of the water coming from the tap. You can adjust the temperature easily by watching the dial as you change the rate of flow of either the hot or the cold water.*

*Darkroom plumbing accessories and dial thermometers, such as those manufactured by Pfefer Products (pictured above), are stocked by many photo dealers.*

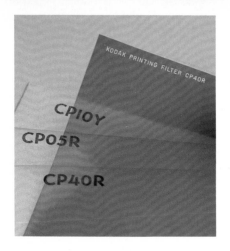

## COLOR PRINTING— STEP BY STEP

1. Place a No. 2B or CP2B filter permanently into the enlarger above the negative carrier.

2. Put your dust-free color negative into the enlarger so that the emulsion side (dull side) is toward the enlarger lens. Set the enlarger for the magnification you want.

3. Select a starting filter pack. Make your first test print using a filter pack of 50M + 90Y. Since light quality, optical components, filters, and dial settings may vary considerably among enlargers, this filter pack is only a starting point. If the color balance of the resulting print is not satisfactory, try a different filter or combination of filters. See steps 6 and 7. Once you've made a good print from a typical negative, you can use the same new filter pack for trial exposures with other negatives.

4. Using the starting filter pack selected, make a test series of four exposures onto one sheet of paper. Make the tests at the same magnification you're going to use for your final print. Expose each section for 10 seconds—one at $f/5.6$, one at $f/8$, one at $f/11$, and one at $f/16$.

5. Process the paper according to the instructions packaged with the chemicals. (See pages 40 through 43.) Dry the print and view it for proper color appearance. When wet, EKTACOLOR Papers have a bluish tint, which makes color-balance determination practically impossible until a print is dry. However, with a portable hair dryer you can dry a print in about a minute or two after removing excess surface water with a squeegee or damp, soft sponge.

6. Judge the best exposure area for proper color. Look at sensitive areas, such as neutrals or flesh tones. Make two decisions: (a) What *color* is in excess? Use the illustrations on pages 34 and 35 as guides. (b) How *much* is that color in excess? Slight, considerable, or great?

7. Apply these decisions to Table 1 on page 36. Correct your starting filter pack (if necessary) by adding or subtracting the filtration listed under "Change in Filter Pack". Find the corrected exposure time opposite the recommended change. This time is corrected for the new filter pack.

Make a new print at the $f$-number that gave the proper exposure. If you feel that the best exposure is somewhere between the exposures you used for two of your tests, set the lens opening accordingly.

**Example:** You exposed the test print using CP Filters and an enlarger having a tungsten lamp. The starting filter pack was 50M + 90Y. Exposures on the test print were 10 seconds at $f/5.6$, $f/8$, $f/11$, and $f/16$. The $f/8$ area is best for density. It is slightly cyan. In the TOO CYAN part of the table, Slight calls for subtracting 10M and 10Y from your starting filter pack. This gives you 40M + 80Y for your

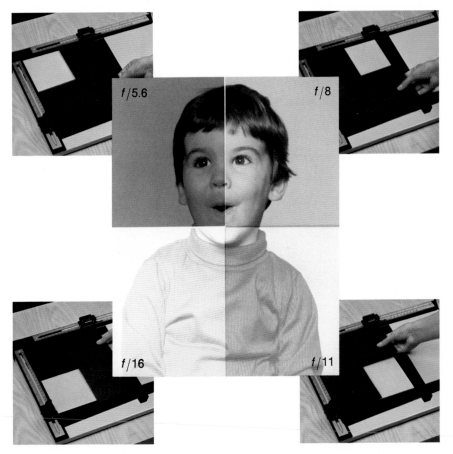

_You can make a test print like the one above by starting with a piece of cardboard the same size as your photographic paper. Cut a rectangular notch extending into the center from one corner of the cardboard. Lay this notched cardboard over the paper on the enlarger easel. To expose each corner of the paper, simply rotate or flip over the cardboard between exposures. Use the same exposure time for each section—change only the lens opening._

new filter pack. The new exposure is 8 seconds at _f_/8.

8. As you gain experience, this corrected print will often be a good one. If the print needs further color correction, use Table 2. When you use Table 2, increase the exposure time 10 percent for each filter you add, and decrease the exposure time 10 percent for each filter you remove to allow for the change in the number of filter surfaces.* (No exposure compensation would be necessary if your enlarger has dichroic color-printing filters built into the lamphouse since the number of filter surfaces would not change.)

---

*For an alternate and more precise method of figuring exposure compensation, use the table on page 37.

40R

These color prints will help you obtain the best color balance and exposure for your prints. We've illustrated two degrees of color variation from normal for each of the six colors—magenta, red, yellow, green, cyan, and blue.

20R

The prints with the smaller color-balance deviation differ from the normal print by a filter strength of 20. That is, if you added a 20 filter of the color in excess to the printing filter pack, the result would be the normal print. When you use Table 1 on page 36, the off-balance of these prints should be judged considerable.

The prints with the greater amount of color-balance deviation differ from the normal print by a filter strength of 40. If you added a 40 filter of the color in excess to the printing filter pack, the result would be the normal print.

40M

20M

20B

40B

40Y

1 stop overexposed

20Y

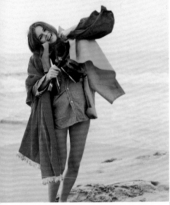

Normal

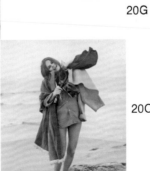

20G

40G

20C

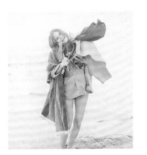

1 stop underexposed

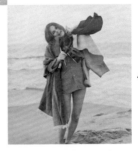

40C

## Table 1. Changes in CC or CP Filters and Exposure Time

| Amount of Color Variation from Normal | | Change in Filter Pack | Approximate Exposure Time (in seconds) for New Filter Pack* |
|---|---|---|---|
| TOO RED | Slight | Add 10M and 10Y | 14 |
| | Considerable | Add 20M and 20Y | 17 |
| | Great | Add 30M and 30Y | 20 |
| TOO GREEN | Slight | Subtract 10M | 8 |
| | Considerable | Subtract 20M | 7 |
| | Great | Subtract 30M | 6 |
| TOO BLUE | Slight | Subtract 10Y | 9 |
| | Considerable | Subtract 20Y | 9 |
| | Great | Subtract 30Y | 9 |
| TOO CYAN | Slight | Subtract 10M and 10Y | 7 |
| | Considerable | Subtract 20M and 20Y | 6 |
| | Great | Subtract 30M and 30Y | 6 |
| TOO MAGENTA | Slight | Add 10M | 13 |
| | Considerable | Add 20M | 15 |
| | Great | Add 30M | 17 |
| TOO YELLOW | Slight | Add 10Y | 11 |
| | Considerable | Add 20Y | 11 |
| | Great | Add 30Y | 11 |

*Based on the use of 10 seconds as the original exposure time.

## Table 2. Final Change in Filter Pack (if needed)

| Appearance of Previous Print | Amount of Change Desired | | |
|---|---|---|---|
| | Very Slight | Slight | Considerable |
| TOO RED | Add 05M and 05Y | Add 10M and 10Y | Add 20M and 20Y |
| TOO GREEN | Subtract 05M | Subtract 10M | Subtract 20M |
| TOO BLUE | Subtract 05Y | Subtract 10Y | Subtract 20Y |
| TOO CYAN | Subtract 05M and 05Y | Subtract 10M and 10Y | Subtract 20M and 20Y |
| TOO MAGENTA | Add 05M | Add 10M | Add 20M |
| TOO YELLOW | Add 05Y | Add 10Y | Add 20Y |

Some color-head enlargers have an additive (tricolor) filtration system consisting of three tungsten-halogen lamps in a single head (lamphouse). Each lamp is beamed through a separate, additive dichroic filter—red, green, or blue. Filter control knobs are labeled so that you don't have to think in terms of opposites (complementary colors) when making color balance adjustments. For example, if you determine that your print is too red, you simply turn the dial marked "RED" to a *lower* setting. Actually, the intensity of red filtration will *increase*,* but because the dial works backward, you skip one big mental step and make your adjustment easier.

*To *reduce* a color in printing EKTACOLOR Papers, you *add* that color to the filter pack.

36

## Exposure Adjustments for Filter-Pack Changes

You don't have to change exposure time when adjusting dichroic filter settings on color-head enlargers. But with enlargers that use CC or CP filters, you must make allowance for the change in filtering action and the change, if any, in the number of filter surfaces. The following table provides a method of determining such exposure adjustments. The filter factors include allowance for the loss of light caused by reflections from the filter surfaces. This table is most convenient when you are changing the pack by only one filter.

### Factors for KODAK CC and CP Filters

| Filter | Factor | Filter | Factor |
|--------|--------|--------|--------|
| 05Y | 1.1 | 05R | 1.2 |
| 10Y | 1.1 | 10R | 1.3 |
| 20Y | 1.1 | 20R | 1.5 |
| 30Y | 1.1 | 30R | 1.7 |
| 40Y | 1.1 | 40R | 1.9 |
| 50Y | 1.1 | 50R | 2.2 |
| 05M | 1.2 | 05G | 1.1 |
| 10M | 1.3 | 10G | 1.2 |
| 20M | 1.5 | 20G | 1.3 |
| 30M | 1.7 | 30G | 1.4 |
| 40M | 1.9 | 40G | 1.5 |
| 50M | 2.1 | 50G | 1.7 |
| 05C | 1.1 | 05B | 1.1 |
| 10C | 1.2 | 10B | 1.3 |
| 20C | 1.3 | 20B | 1.6 |
| 30C | 1.4 | 30B | 2.0 |
| 40C | 1.5 | 40B | 2.4 |
| 50C | 1.6 | 50B | 2.9 |

## Exposure Adjustments for Enlarger-Height Changes

As you raise or lower the enlarger to change the image size on the easel, the brightness of that image will also change. For example, as the enlarger goes higher, the projected image gets larger. Because the lamp brightness remains constant, the image becomes dimmer as it grows since the same amount of light must now cover a larger surface area. To compensate for this loss in overall image brightness, you must increase the exposure.

You can use the following formula to determine a new exposure time when changing the enlarger height (easel-to-lens distance):

$$\text{New time} = \text{Old time} \times \frac{\text{New enlarger height}^2}{\text{Old enlarger height}^2}$$

Let's say that on a 4 x 5-inch (10.2 x 12.7 cm) print you are pleased with the exposure of 8 seconds at $f/11$. You now want to make an 8 x 10-inch (20.3 x 25.4 cm) print from the same negative. The distance from the easel to the enlarger lens was 10 inches. After raising the enlarger and focusing the lens to produce an 8 x 10-inch image, you again measure the enlarger height and find that this distance is 20 inches (50.8 cm).

$$\text{New time} = 8 \times \frac{20^2}{10^2}$$

$$\text{New time} = 8 \times \frac{400}{100}$$

New time = 32 seconds (To shorten exposure time, open the lens aperture to $f/8$ for 16 sec or $f/5.6$ to keep the previous 8-second time.)

# YOUR STANDARD NEGATIVE

A standard control negative is a normal negative that has been properly exposed under known conditions and that is known from trial to make an excellent print. As you've printed it previously, you have an accurate record of the filter pack required for your particular equipment and paper emulsion. You can use this standard negative for comparing its printing characteristics with those of other color negatives as well as for comparing different paper emulsions and for checking processing.

Your standard negative should be typical of the majority of negatives you will be printing. If most of your negatives are outdoor shots on KODACOLOR VR 200 Film, your standard negative obviously should be an outdoor shot on KODACOLOR VR 200 Film. Further, it should be of a typical subject with typical lighting, normally exposed and normally processed.

Choose for your standard negative an image containing some areas that are relatively sensitive to minor color-balance changes. For example, sunsets or flowers are not good test objects because you can often make pleasing prints of them over a wide range of color balances. However, the face in a portrait is a sensitive area, as is any near-neutral, like a concrete surface. Professional photographers often include in the scene a gray scale or a card of 18-percent reflectance; for example, the gray side of the KODAK Gray Card (Publication No. R-27). Such gray areas will quickly aid you in evaluating even slight color-balance deviations.

Most color negatives of the same type of subject exposed under similar conditions will print similarly. Slight differences will result from variations

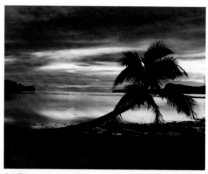

80R

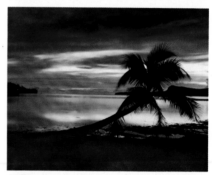

65R

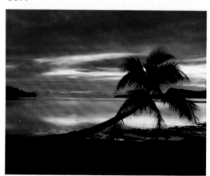

50R

*When selecting your standard negative, avoid negatives of subjects that would make pleasing prints over a wide range of color balances. These three prints all would be acceptable to most people when viewed separately, even though each was made with a substantially different filter pack.*

in lighting (time of day, sky condition, etc), variations in film emulsion color balance, or variations in film processing. These differences are normal. Just think of these balance variations in terms of filter differences between each negative and your standard negative.

Here's a way to use your standard negative for helping you quickly make good prints from other negatives. Each time you begin using a new paper emulsion, first make a normal print from your standard negative and record the filter pack you used. Suppose the filter pack for making a normal print from the standard negative is 40M + 80Y, and the best exposure time is 10 seconds. This filter pack and exposure time become the starting point for similar negatives. You find that a new negative you're printing actually requires adding a 10M filter to the pack, now making the pack 50M + 80Y. You also need to adjust the exposure time to 12 seconds to compensate for differences between the new negative and the standard negative. The new negative prints differently from your standard negative by a 10M filter and a 20-percent increase in time.

Record this information with the new negative. These differences will remain constant regardless of the color balance in paper emulsions that you use in the future. For example, you might want to make a reprint of this new negative a year later on a different paper emulsion. The basic filter pack to print your standard negative has become a 20M + 80Y (a difference of -20M) with the paper you're using now. All you'll have to do is increase the exposure by 20 percent and add a 10M filter to this pack to make a normally balanced print without further test. Your adjusted pack for the new negative being reprinted would be 30M + 80Y.

*From a color printing standpoint, faces and gray cards are sensitive areas, making good subject ingredients for standard negatives.*

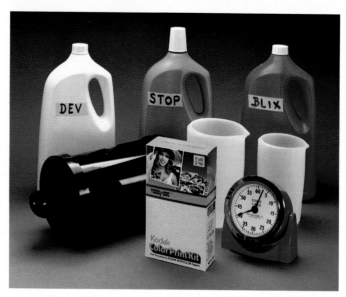

*The KODAK HOBBY-PAC Color Print Kit makes enough working solutions to tube-process about 10 8 x 10-inch prints.*

# PROCESSING *KODAK EKTACOLOR* PAPERS

KODAK HOBBY-PAC Color Print Kit contains all the chemicals you'll need to process KODAK EKTACOLOR Papers in tubes.

## Solutions

The photographic quality and life of processing solutions depend upon the cleanliness of the equipment in which the solutions are mixed, stored, and used. The contamination of any chemical solution by any other is to be avoided, since it will seriously impair print quality. Take extreme care to avoid contamination of the developer with bleach-fix during mixing and processing, and always keep your equipment clean.

## Time and Temperature

Control of the solution temperatures and the time of the different processing steps is very important for maintaining consistent color balance and density in your color prints. For best results, your EKTACOLOR Paper should be processed at 90 ± 1°F (32.2 ± 0.6°C), but acceptable results can be achieved as low as 66°F (19°C)

### Time/Temperature Table for Processing KODAK EKTACOLOR Papers

| TEMPERATURE | | DEVELOPER TIME |
|---|---|---|
| °F | °C | (min,sec) |
| 100 | 38 | 2'10" |
| 98 | 37 | 2'15" |
| 96 | 36 | 2'20" |
| 94 | 34 | 2'30" |
| 92 | 33 | 2'45" |
| 90 | 32 | 3'00" |
| 88 | 31 | 3'30" |
| 86 | 30 | 3'50" |
| 84 | 29 | 4'30" |
| 82 | 28 | 5'10" |
| 80 | 27 | 6'00" |
| 78 | 26 | 7'30" |
| 76 | 24 | 8'45" |
| 74 | 23 | 10'30" |
| 72 | 22 | 12'15" |
| 70 | 21 | 15'00" |
| 68 | 20 | 17'00" |
| 66 | 19 | 19'00" |

and as high as 100°F (38°C). But whatever temperature you pick, carefully maintain it and use the corresponding developing time for that temperature. You need a different developing time for any change in temperature because the action of the developer slows as the temperature drops. The table on page 40 shows developing times according to temperature.

The temperature control of the stop bath and bleach-fix is important, but less critical.

## Tube Processors

Tube processors (sometimes called daylight-drum processors) are lighttight canisters made specially for processing color papers. Tube processors are inexpensive both to purchase and use because they require ony minimum volumes of processing solutions. A typical tube designed for processing 8 x 10-inch prints requires about

*Processing tubes are lighttight canisters made specially for processing color paper. They're made by several manufacturers. See your photo dealer.*

### Processing KODAK EKTACOLOR Papers in Tube Processors

● **Processing Steps**

| PROCESSING STEP | TIME (min) | AMOUNT OF SOLUTION (ML)* PER TUBE SIZE | | |
| --- | --- | --- | --- | --- |
| | | 8 x 10 | 11 x 14 | 16 x 20 |
| Prewet | ½ | 500† | 1000· | 1500· |
| Developer | From TIME/TEMPERATURE TABLE | 70 | 130 | 260 |
| Stop Bath | ½ | 70 | 130 | 260 |
| Bleach-Fix | 1 (80 to 100°F) 1½ (66 to 79°F) | 70 | 130 | 260 |
| Wash | ½ ½ ½ ½ | 500† 500† 500† 500† | 1000† 1000† 1000† 1000† | 1500† 1500† 1500† 1500† |
| | Additional washing aids print stability. | | | |
| Dry (as required) | Not over 200°F (93°C) | | | |

* 70 mL = 2.4 fl oz   500 mL = 17 fl oz   †Some processing tubes will not hold the
130 mL = 4.4 fl oz   1000 mL = 34 fl oz   indicated volume. In such cases,
260 mL = 8.8 fl oz   1500 mL = 51 fl oz   fill with as much water as possible.

70 mL (2.4 fl oz) of each chemical solution per print. Actual volumes might vary slightly, depending upon the manufacturer, so check with your specific tube instructions for recommended volumes.

## Procedure A

Keep your tube processor, along with your bottles of solutions, in a constant-temperature water bath during the processing steps. For an even distribution of each solution, the tube must be level. If your tube has any kind of opening that would allow water to enter during the processing steps, use Procedure B.

## Procedure B

Use the water bath only for holding solutions at proper temperature. Carry out all processing steps on a level surface (not in the water bath). Remember that the tube *must* be level for even distribution of each solution.

Since Procedure B is run outside the water bath, heat will transfer between the processor and the surroundings. To get an average developer temperature of 91°F (33°C), run the following test:

1. Place a scrap sheet of photographic paper into the tube. (Load the tube according to the instructions packaged with it.)
2. Follow the prewet and developer steps using the correct volumes and times. The prewet and "developer" (substitute water for the developer in this test) should be at the temperature of the water bath before running the process.

*A deep tray works well as a jacket for the water bath. You can put your premeasured processing solutions in small, glass, food jars. The combined weight of the glass and the solutions reduces buoyancy and the danger of spills while in the water bath. Avoid accidents—keep the jars out of reach of children!*

## Processing KODAK EKTACOLOR Papers in Tube Processors

| No. of Prints | of this size | Volume of Chemicals per print |
|---------------|--------------|-------------------------------|
| 10 | 8 x 10 | 2.4 fl oz  (70 mL) |
| 6 | 11 x 14 | 4.4 fl oz (130 mL) |
| 3 | 16 x 20 | 8.8 fl oz (260 mL) |

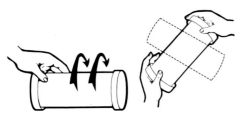

*Agitation is very important. Be sure to follow the agitation procedures recommended by the manufacturer of the processing tube you are using.*

3. At the end of the developer step, collect the water from the tube and measure the temperature. When averaged with the water bath temperature, the result should be 91°F.

For a room temperature of 75°F (24°C), the water bath is typically 95°F (35°C) and the temperature of the developer after the processing step would be 88°F (31°C). The average of 95°F and 88°F would be 91°F, the recommended temperature.

After the bleach-fix step, you can remove the print from the tube for washing in a tray under normal room light. Agitate and dump the wash water, and refill the tray four times.

Do not reuse the chemicals. To prevent contamination and make loading easier, always clean and dry the tube after each process.

## Drying

Before drying your prints, squeegee or sponge the surfaces on both sides to remove excess moisture. Dry the prints in a dustfree place and do not ferrotype them. Allow for good air circulation by putting them emulsion-side up on towels, on a line using spring clothespins, or on a specially designed drying rack. You can greatly reduce the drying time by blowing hot air onto prints with a portable home hair dryer. Keep the dryer moving so that the hot air is not concentrated in one spot too long. The temperature of the air should be below 200°F (93°C).

*Color negative printed on* KODAK EKTACOLOR PLUS *Paper.*

# MAKING BLACK-AND-WHITE ENLARGEMENTS FROM COLOR NEGATIVES

You can make high-quality black-and-white enlargements from your color negatives. By printing directly onto a panchromatic paper, like KODAK PANALURE II RC or KODAK PANALURE II Repro RC Papers, you can make prints much in the same way that you print black-and-white negatives onto ordinary (orthochromatic) photographic paper.

## KODAK PANALURE II RC and II Repro RC Papers

When you print a color negative onto PANALURE II RC Papers—which are sensitive to red, green, and blue light—all colors in the picture are rendered in appropriate tones of gray.

PANALURE II RC Papers have resin-coated bases which allow rapid processing and drying. PANALURE II Repro RC Paper is one grade lower in contrast than PANALURE II RC Paper. They are available in the F (smooth glossy) surface with a warm-black tone. The F surface requires no ferrotyping to achieve the gloss. Just dry the paper as you would any other resin-coated paper (page 43).

Handle PANALURE II RC Papers by the light of the same safelight you would use for EKTACOLOR Paper de-scribed on page 29. Or you can process the paper in total darkness, because the safelights normally used for processing black-and-white papers will fog PANALURE Papers.

When you print color negatives onto PANALURE II RC Papers, you have the advantage of controlling tone rendition by using a filter with your enlarger when exposing the print. This creates the same effect that would have resulted if you had used panchromatic black-and-white film and a filter over your camera lens when you shot the picture. The rules for using filters with PANALURE II RC Papers are the same as those for using filters on your camera when you photograph the original scene on panchromatic black-and-white film. To lighten a color, use a filter of a similar color. To darken a color, use a filter of a complementary color. For example, you can expose your print through a No. 15 deep-yellow or a No. 25 red filter to darken a blue sky.

You'll find exposing and processing information in the instruction sheet that comes with the paper. PANALURE II RC Papers can be processed in KODAK HOBBY-PAC™ Black-and-White Paper Processing Kit.

*Color negative printed on KODAK PANALURE Paper—no filter.*

*A No. 25 red filter was used during printing. Notice how the filter darkened the blue towel and lightened the red towel.*

# PRINTING COLOR SLIDES USING *EKTACHROME 22* PAPER

You can choose between two different methods to make color prints from your color slides. You can print them directly onto KODAK EKTACHROME 22 Paper or have color internegatives made from your slides. Once you have the internegatives, you can print them just like color negatives which have been exposed in your camera, using the same printing paper and chemicals described earlier for printing color negatives.

To have internegatives made from your color slides, take them to your photo dealer. Kodak Processing Labs will make KODAK Color Negatives from your color transparencies at a cost of approximately $3 each. The sizes of the negatives are $2^{1}/_{4}$ x $3^{1}/_{4}$ inches (57 x 83 mm) from full-frame and half-frame 135 slides; $2^{1}/_{4}$ x $2^{1}/_{4}$ inches (57 x 57 mm) from square slides.

Original
color slide

Internegative

Print on EKTACHROME Paper

If you have many slides from which you want to make prints, you'll find it more economical to print your color slides directly onto EKTACHROME 22 Paper without paying to have internegatives made. KODAK EKTACHROME 22 Paper can be processed in small tube-type processors using the new KODAK HOBBY-PAC™ Color Reversal Print Kit designated for processing EKTACHROME 22 Paper. This one kit allows the small-volume user to make prints directly from color slides without having to purchase large quantities of chemicals.

Don't attempt to process the paper in trays. The chemicals become exhausted within a short time once coming into contact with the air, making the technique uneconomical. In addition, it might be difficult to maintain consistent temperature and agitation for quality results.

**CAUTION:** Do not process KODAK EKTACHROME 2203 or 14 Paper with this kit.

Print on EKTACOLOR Paper

This picture was reproduced from a print on KODAK EKTACHROME Paper of a 35 mm EKTACHROME Film slide. The filter pack was 15C + 25M. Remember that cyan-2 (C-2) filters used for printing EKTACOLOR Papers have slightly different absorption characteristics and are not recommended for printing color transparencies.

# WHAT YOU'LL NEED

You can use most of the same equipment that is used for printing color negatives. You'll need some additional filters because, unlike when printing color negatives, printing onto EKTACHROME Paper requires cyan filtration. In addition to the CP or CC filters listed on page 30, you may need one of the filter groups below:

| CP filters (for enlargers with filter drawer between lamp and slide) | |
|---|---|
| CP025C | CP20C |
| CP05C | CP40C |
| CP10C | |

| CC filters (for enlargers requiring filter placement below the lens) | |
|---|---|
| CC025C | CC30C |
| CC05C | CC34C |
| CC10C | CC50C |
| CC20C | |

Another series of cyan filters is available in the above densities. These filters, having the suffix "-2," can be used with EKTACOLOR Papers but not with EKTACHROME Paper because they have slightly different absorption characteristics.

## Paper

KODAK EKTACHROME 22 Paper is a water-resistant *reversal* color material for direct printing and enlarging of slides of KODACHROME or EKTACHROME Film. Since the paper produces a positive picture from a slide (positive to positive), its reaction to light is opposite that of other photographic papers (negative to positive). As EKTACHROME Paper receives more exposure, the image becomes lighter, while less exposure yields a darker print. Therefore, picture border areas which receive no exposure turn out black. Store EKTACHROME Papers at 55°F or lower. Being sensitive to all visible colors of the spectrum, EKTACHROME Paper must be handled in total darkness before and during processing.

You can get the paper in a variety of sizes and sheet quantities in both F (glossy) and N (smooth, lustre) surfaces.

### KODAK EKTACHROME 22 Paper

| Sheets per Package | Size (inches) | Surface |
|---|---|---|
| 10 | 8 x 10 | F&N |
| 25 | 8 x 10 | F&N |
| 100 | 8 x 10 | F&N |
| 10 | 11 x 14 | F&N |
| 50 | 11 x 14 | F&N |
| 10 | 16 x 20 | F&N |
| 50 | 16 x 20 | F&N |
| 50 | 20 x 24 | F&N |
| 50 | 30 x 40 | F&N |

## Chemicals

For processing EKTACHROME Paper in a tube processor, the KODAK HOBBY-PAC Color Reversal Print Kit for EKTACHROME 22 Paper is recommended. A summary of the steps for processing the paper appears later in this chapter. You'll find additional instructions included with the kit.

# MAKING A PRINT

Printing color slides directly onto EKTACHROME 22 Paper is somewhat similar to printing color negatives onto EKTACOLOR Papers. The main difference is that the corrections you make in exposure time and filtration are just the reverse of the corrections you make when printing color negatives. It is convenient to see the color pictures projected onto your enlarging easel with normal color relationships rather than as a negative image, and it's easier to judge printing-filter corrections than with color negatives.

*Depending on your enlarger film-carrier design, you may find it necessary to remove your slide from its mount before putting it into the enlarger. Be especially careful to avoid fingerprints and dust—they would appear on the finished print as ugly black distracting marks.*

*It's easy to crop, size, and focus a slide on the enlarging easel, because you can see the image in its normal form, as a projected positive.*

## COLOR PRINTING— STEP BY STEP

1. Make sure that your slide is free from dust and place it into the enlarger so that its emulsion side is toward the lens. (In this position, the projected image will appear in the proper orientation on the easel.) Eliminate any stray light around the edges of the slide by masking it with black paper or black masking tape.

2. Place a UV absorber, i.e., a KODAK WRATTEN Filter No. 2B or 2E, and a heat-absorbing glass between the enlarger light source and the slide.

3. For a starting filter pack, try 30 cyan plus 40 magenta (30C + 40M).

4. With the enlarger elevated to make an 8 x 10-inch (20.3 x 25.4 cm) enlargement from a 35 mm slide, make a series of exposures at 5, 10, and 20 seconds at $f/5.6$.

5. Process and dry the test print. (Prints from EKTACHROME Paper have an opalescent cast when wet.) After the print is dry, choose the exposure you like the best, and evaluate the color balance as described in the next section.

6. Make your estimated filter-pack corrections, and expose another print at the selected time and $f$-stop. Once again, process, dry, and evaluate the print.

7. When you are satisfied that the density (exposure) and color balance are correct, record the filter pack and exposure information. All similar transparencies of the same film type should produce equally good prints when printed with the same filter pack and exposure (at the same degree of enlargement).

Use these new filter-pack and exposure data as a starting point for

**20 sec**

**10 sec**

**5 sec**

**To make a test print:**
*(1) Give the entire sheet of paper a 5-second exposure.*
*(2) Cover a third of the paper with a piece of cardboard, and turn on the enlarger for another 5 seconds.*
*(3) Finally, move the cardboard to cover two-thirds of the paper, and expose the remaining uncovered portion for 10 seconds. The resulting print will have a series of exposures at 5, 10, and 20 seconds.*

determining the standard printing condition for other types of transparencies.

In making test exposures, don't use the KODAK Projection Print Scale (used in black-and-white enlarging).

Because of variations in sensitivity of the emulsion layers with illumination level and exposure time, this device will not lead to reliable exposure predictions.

## Adjusting the Filter Pack

The simplest way to check the color balance of a print is to compare it with the original slide. Take a look at midtone areas in the print to see if they vary in color from the same areas in the slide.

40R

20R

If you've made prints on EKTACOLOR Paper from color negatives, you will find that it takes a greater change in filter pack to correct color balance with EKTACHROME Paper. For a very slight change in color appearance, first try a 10 CP or 10 CC filter-pack change—then more or less, if needed.

When making filter corrections to the printing filter pack, remove filters from the pack whenever possible. For example, if a test print is reddish in balance, remove yellow and magenta filters rather than adding cyan filters.

40M

20M

The filter pack should not contain more than two colors of the subtractive filters (cyan, magenta, and yellow). The effect of all three is to form neutral density, which lengthens the exposure time without accomplishing any color correction. To eliminate neutral density, remove the filters of one color entirely, and remove the same density value of each of the other two colors.

20B

40B

| If color balance is: | subtract these filters | or add these filters |
|---|---|---|
| Yellow | Yellow | Magenta + Cyan |
| Magenta | Magenta | Yellow + Cyan |
| Cyan | Cyan | Yellow + Magenta |
| Blue | Magenta + Cyan | Yellow |
| Green | Yellow + Cyan | Magenta |
| Red | Yellow + Magenta | Cyan |

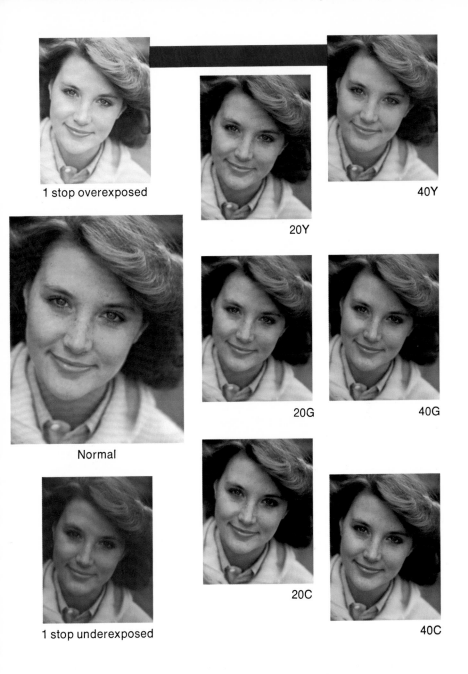

1 stop overexposed

20Y

40Y

Normal

20G

40G

1 stop underexposed

20C

40C

*You can refer to these prints made on KODAK EKTACHROME Paper to determine the degree of color correction needed for your own prints. Since you're working with a positive-to-positive process, making filter-pack adjustments is extremely easy. For example, the prints with the smaller color-balance deviation differ from the normal print by a filter strength of 20. If you subtract a 20 filter of the color in excess to the printing pack, the result will be a normal print.*

*The print at left is 20M heavy in color balance. Since its filter pack has no magenta filtration to subtract, we added 20 green (20C + 20Y), which is the complement of magenta, to the pack to correct the color balance.*

|  |  |
|---|---|
| Old pack | 00C + 10Y |
| Change | + 20C + 20Y |
|  | 20C + 30Y |

## Adjusting Your Exposure

No exposure compensation is necessary when changing dial settings on an enlarger that has built-in dichroic filters. But with enlargers using CC or CP filters, you must allow for a change in exposure introduced by (a) the change in filtering action and (b) the change, if any, in the number of filter surfaces. Otherwise, the density of the corrected print will differ from that of the test print.

*By multiplying the exposure time by the appropriate filter factors on page 37, we determined that the new filter pack required a 6-second exposure-time increase to compensate for the added filtration.*

00C + 10Y, 15 sec
20C + 30Y, 21 sec

If you change the pack by only one filter, use the appropriate filter factor in the table on page 37. Otherwise, you may prefer using the Color-Printing Computer in the KODAK Complete Darkroom DATAGUIDE (Publication No. R-18).

To adjust exposure for enlarger-height changes, you can use the formula on page 37.

# TUBE PROCESSING
## *KODAK EKTACHROME* 22 PAPER

Processing EKTACHROME 22 Paper in a tube processor with KODAK HOBBY-PAC Color Reversal Print Kit requires 10 steps. The recommended processing temperature is 100°F (38°C), but acceptable results can be achieved as low as 70°F (21°C). Read the following two procedures and set up your processing area after you decide which to use, Procedure A or Procedure B. The design of the tube will dictate the procedure you use.

### Procedure A

Process in a constant-temperature bath (for tubes that can be submersed). *Keep the tube watertight during the processing procedure.*

Perform the processing steps, including agitation, with the tube-type processor in the constant-temperature bath. For a complete, even process, keep the tube level (flat) to allow even solution distribution. If your processing tube is not watertight, use Procedure B.

Although the recommended processing temperature is 100°F (38°C), this is not always possible, especially if a constant-temperature bath is not used. Once the processing temperature has been selected—it must be between 70 and 100°F (21 and 38°C)—the appropriate first and color-development times can be obtained from the table on page 57.

### Procedure B

Processing steps, including agitation recommendations, should be done on a level surface (not in the constant-temperature bath). Remember, the tube MUST be level (flat) to allow an even distribution of each solution.

Since Procedure B is run outside a constant-temperature bath, heat can be transferred between the processor and the surroundings. To obtain an average temperature of 100°F (38°C), use the following starting temperatures for the solutions:

| For Room Temperature | | Use Starting Temperature | |
|---|---|---|---|
| °F | °C | °F | °C |
| 70 | 21 | 114 | 45.5 |
| 75 | 24 | 112 | 44.5 |
| 80 | 26.7 | 110 | 43.5 |
| 85 | 29.5 | 108 | 42.2 |
| 90 | 32 | 106 | 41 |

# Time/Temperature Table for Processing
## KODAK EKTACHROME 22 Paper

Time at Various Temperatures—Min, Sec

| Process Temperature °F | °C | Prewet | First Developer | Wash* | Wash* | Wash* | Color Developer | Wash* | Wash* | Bleach Fix | Wash** | Total Time |
|---|---|---|---|---|---|---|---|---|---|---|---|---|
| 68 | 20 | 1 min | 8' | 40" | 40" | 40" | 18'30" | 45" | 45" | 6'30" | 3'15" | 40'45" |
| 69.8 | 21 | 1 min | 7' | 40" | 40" | 40" | 16'15" | 45" | 45" | 6'15" | 3'15" | 37'15" |
| 71.6 | 22 | 1 min | 6' | 40" | 40" | 40" | 14' | 45" | 45" | 6' | 3'15" | 33'45" |
| 73.4 | 23 | 1 min | 5'30" | 40" | 40" | 40" | 12'15" | 45" | 45" | 5'45" | 3'15" | 31'15" |
| 75.2 | 24 | 1 min | 4'45" | 40" | 40" | 40" | 10'30" | 45" | 45" | 5'30" | 3'15" | 28'30" |
| 77.0 | 25 | 1 min | 4'30" | 40" | 40" | 40" | 9'15" | 45" | 45" | 5'15" | 3'15" | 26'45" |
| 78.8 | 26 | 1 min | 4' | 40" | 40" | 40" | 8' | 45" | 45" | 5' | 3'15" | 24'45" |
| 80.6 | 27 | 1 min | 3'45" | 40" | 40" | 40" | 7'15" | 45" | 45" | 4'45" | 3'15" | 23'30" |
| 82.4 | 28 | 1 min | 3'15" | 40" | 40" | 40" | 6'15" | 45" | 45" | 4'30" | 3'15" | 21'45" |
| 84.2 | 29 | 1 min | 3' | 40" | 40" | 40" | 5'45" | 45" | 45" | 4'15" | 3' | 20'30" |
| 86.0 | 30 | 30 s | 2'45" | 20" | 20" | 20" | 5'15" | 20" | 20" | 4' | 2'15" | 16'25" |
| 87.8 | 31 | 30 s | 2'30" | 20" | 20" | 20" | 5' | 20" | 20" | 3'45" | 2'15" | 15'40" |
| 89.6 | 32 | 30 s | 2'15" | 20" | 20" | 20" | 4'30" | 20" | 20" | 3'30" | 2'15" | 14'40" |
| 91.4 | 33 | 30 s | 2' | 20" | 20" | 20" | 4' | 20" | 20" | 3'15" | 2'15" | 13'40" |
| 93.2 | 34 | 30 s | 1'45" | 20" | 20" | 20" | 3'45" | 20" | 20" | 3' | 2'15" | 12'55" |
| 95.0 | 35 | 30 s | 1'45" | 20" | 20" | 20" | 3'30" | 20" | 20" | 2'45" | 2'15" | 12'25" |
| 96.8 | 36 | 30 s | 1'30" | 20" | 20" | 20" | 3' | 20" | 20" | 2'30" | 2'15" | 11'25" |
| 98.6 | 37 | 30 s | 1'30" | 20" | 20" | 20" | 2'45" | 20" | 20" | 2'15" | 2'15" | 10'55" |
| 100.4 | 38 | 30 s | 1'15" | 20" | 20" | 20" | 2'15" | 20" | 20" | 2' | 2'15" | 9'55" |

*Wash water poured in like the solutions (2 or 3 times the volume of processing solution)
**Wash with running water and open tank

## Processing KODAK EKTACHROME 22
## Paper in Tube Processors

| PROCESSING STEP | Time | | AMOUNT OF SOLUTION (ML)* PER TUBE SIZE | | |
|---|---|---|---|---|---|
| | 86–100°F (30–38°C) | 70–84°F (21–29°C) | 8 x 10 | 11 x 14 | 16 x 20 |
| Prewet | 30 sec | 1 min | 250–300† | 400–500† | 800–1000† |
| First Developer | From TIME/ TEMPERATURE TABLE | | 70 | 130 | 260 |
| Wash | 30 sec 30 sec 30 sec | 45 sec 45 sec 45 sec | 250–300† 250–300† 250–300† | 400–500† 400–500† 400–500† | 800–1000† 800–1000† 800–1000† |
| Color Developer | From TIME/ TEMPERATURE TABLE | | 70 | 130 | 260 |
| Wash | 30 sec 30 sec | 45 sec 45 sec | 250–300† 250–300† | 400–500† 400–500† | 800–1000† 800–1000† |
| Bleach-Fix | From TIME/ TEMPERATURE TABLE | | 70 | 130 | 260 |
| Wash | 2 min 15 sec | 3 min 15 sec | Running water—open tank | | |
| | Additional washing aids print stability. | | | | |
| Dry (as required) | Not over 200°F (93°C) | | | | |

* 70 mL  = 2.4 fl oz   260 mL  =   8.8 fl oz   520 mL  = 17.6 fl oz
130 mL  = 4.4 fl oz   280 mL  =   9.5 fl oz   680 mL  = 23.0 fl oz
210 mL  = 7.1 fl oz   390 mL  = 13.2 fl oz   1040 mL  = 35.2 fl oz

†Some processing tubes will not hold the indicated volume. In such cases, fill with as much water as possible.

# PRINT PROCESSING PITFALLS

Be sure that your print is properly exposed. The remedies presented here will not correct exposure problems. Dust spots are very common, so your printing equipment always should be kept dust free. Be very careful not to cause solution contamination.

### Prints on EKTACHROME Paper from transparencies:

| Characteristic | Probable Cause |
| --- | --- |
| Streaks or nonuniformity | Improper agitation. Follow tube manufacturer's recommendations. |
| Stain (overall or partial) | Contamination. Use each container for one solution only; wash thermometer between solutions. |
| Washed-out color, not caused by exposure problem. | Insufficient drain time. Be sure to drain the tube completely between steps. |

### Prints on EKTACOLOR Paper from negatives:

| Characteristic | Probable Cause |
| --- | --- |
| High contrast, cyan stain, or high cyan contrast (pink highlights and cyan shadows) | Developer too concentrated.<br>Bleach-fix contamination of developer or of prewet.<br>Long developer time or high process temperature. |
| Magenta-blue streaks | Insufficient stop bath action (stop bath exhausted, contaminated, or not used). |
| Pink streaks | Water on print prior to processing. Caused by inadequate drying of tube and cap. |
| Light and dark streaks | Prewet not used.<br>Insufficient developer agitation.<br>Processor tube not level. |
| Blue blacks | Diluted developer (mixing error).<br>Insufficient developer time.<br>Insufficient drain time after prewet. |
| Low contrast (especially magenta-pink highlights and green shadows) | Diluted developer.<br>Insufficient volume of developer.<br>Not enough agitation.<br>Incorrect developer time or temperature. |

# PRINTING COLOR NEGATIVES AND SLIDES USING ▮▮▮▮ *KODAK EKTAFLEX PCT* PRODUCTS

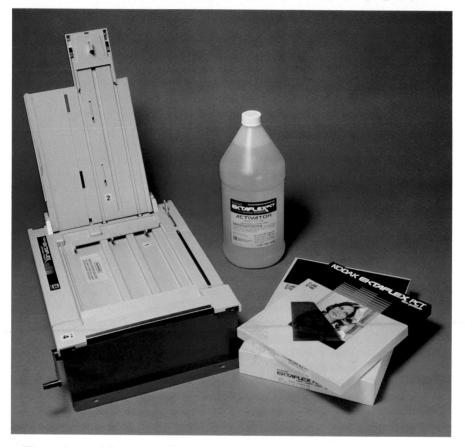

The easiest, quickest way of printing color negatives and slides is with KODAK EKTAFLEX PCT Products. The only products needed are the KODAK EKTAFLEX Printmaker, KODAK EKTAFLEX PCT Film (negative film for prints from color negatives, reversal film for prints from color slides), KODAK EKTAFLEX PCT Paper, and KODAK EKTAFLEX PCT Activator.

The activator is the only chemical you'll need. It requires no mixing and, like the paper, is used for both negative and reversal films. Beautiful color prints can be made without plumbing or trays, and activation and lamination may be done over a range of temperatures.

Once familiar with the process, you can start making creative applications with it. Different effects can be obtained with multiple exposures and multiple laminations of one sheet of film. Exposing a color slide onto negative film will result in an interesting print with reversed tones. For more creative ideas on using EKTAFLEX PCT Products, ask your photo dealer for a copy of *Creative Color: Ideas for Experimenting with KODAK EKTAFLEX PCT Color Printmaking Products* (P10-2T).

## WHAT YOU'LL NEED

- EKTAFLEX Printmaker, Model 8
- EKTAFLEX PCT Negative Film, or
- EKTAFLEX PCT Reversal Film
- EKTAFLEX PCT Paper
- EKTAFLEX PCT Activator
- KODAK 13 Safelight Filter, using $7^1/_2$-watt bulb*
- The same equipment used to expose color negatives listed on page 27.

Assemble and secure the printmaker to a level surface according to the instructions enclosed with your printmaker.

Pour activator into the printmaker up to the top of the fill posts. Wear rubber gloves and protective clothing. The activator is very caustic.

With the negative film, you may use a No. 13 safelight filter with a $7^1/_2$-watt bulb kept at least 4 feet (1.2 metres) from the film for a maximum of 3 minutes. Reversal film must be handled in total darkness. EKTAFLEX PCT Paper is not light-sensitive and may be handled under room lights. And since both the paper and film are opaque, the laminated "sandwich" is lighttight and may be exposed to normal room lights during the image transfer process.

Film is available in 5 x 7-inch and 8 x 10-inch sheets (larger sizes are also available); paper is available in sheets slightly larger than the film. The paper is available in F (glossy) and N (semi-matt) surfaces.

## EXPOSING *EKTAFLEX PCT* FILMS

Choose the type of film appropriate for your needs: EKTAFLEX PCT Negative Film for making prints from color negatives, EKTAFLEX PCT Reversal Film for making prints from color slides. Exposing negative and reversal films is similar to exposing conventional color paper. The only important difference to remember is that you place the negative or slide in your enlarger *emulsion side up* instead of emulsion side down because the image is reversed during the transfer process.

Place the film in the enlarger easel emulsion side up. Reversal and negative sheet films are notched to facilitate orientation and identification; the position of the notch, always in the same location, tells you which is the emulsion side. With the notch in the upper right-hand edge of the film sheet, the emulsion side is facing you.

Make a test print (as described on page 33) starting with a filter pack of 40R (40M and 40Y) for negative film, 10R (10M and 10Y) for reversal film.

---

*Use with negative film only.

## PROCESSING *EKTAFLEX PCT* FILMS

The printmaker has illuminated numbers, which allows you to identify each step in the dark.

To make filter pack and exposure corrections for EKTAFLEX PCT Negative Film, follow the instructions given for EKTACOLOR Papers listed on pages 36–37. To make corrections for EKTAFLEX PCT Reversal Film, follow the instructions given for EKTACHROME Papers listed on pages 52–55. Complete information on exposure times and color correction are also found in the instruction sheet packaged with the film.

When finished processing, drain the activator back into the bottle and seal. Rinse and dry the printmaker.

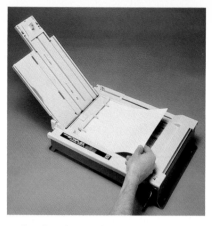

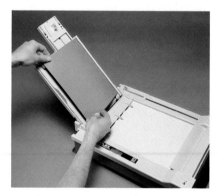

1. Load a sheet of EKTAFLEX PCT Paper onto the paper shelf, *emulsion (white) side down.*

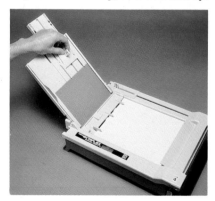

2. Load the exposed sheet of EKTAFLEX PCT Film onto the printmaker ramp, *emulsion side up.*

3. Using the film ramp slide, slide the film into the activator solution and let it soak for *20 seconds.*

## Activator Life

- 72 total hours in the printmaker tray

- 75-8 x 10-inch processed prints (per 3-quart bottle)

- 12 months after opening bottle

### Temperature/Processing Times for EKTAFLEX PCT Negative and Reversal Films

| Room Temperature | | Lamination Time in Minutes | |
|---|---|---|---|
| °F | °C | Negative Film | Reversal Film |
| 65 | 18 | 8 to 15 | 15 to 20 |
| 70 | 21 | 7 to 12 | 12 to 15 |
| 75 | 24 | 6 to 10 | 9 to 12 |
| 80 | 27 | 6 to 10 | 8 to 10 |

4. While turning the hand crank of the printmaker, push the film advance rake forward to laminate the film to the paper. You can turn room lights on now while the "sandwich" of film and paper processes itself, developing the image and transferring it from film to paper.

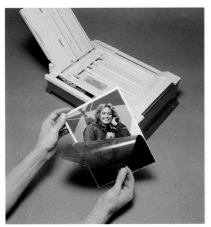

5. Peel the sandwich apart after approximately 6-15 minutes (see table at right). Your print is now finished and damp dry, needing only a few minutes to dry completely. Do not wash prints on EKTAFLEX PCT Paper.

*Print made on* KODAK EKTAFLEX PCT *Paper.*

# PRINTMAKER PROCESSING PITFALLS

| Characteristic | Probable Cause | Solution |
|---|---|---|
| Uneven borders, excess white border at lead end of print. | Paper advanced ahead of film into laminating rollers. | Finger or hand touched plate attached to printmaker paper rake: grasp advance handle up higher. |
| Picture crooked on paper, tapered borders. | Paper crooked going into lamination rollers. | Carefully align paper against far edge of printmaker shelf. |
| Light colored or white areas at tail of print in image area, sharp or soft edges. | Film not fully immersed in activator at beginning of soak. | Check for low activator level. Push printmaker film slide quickly and fully to bottom of the ramp. |
| White or light irregularly shaped patches in print. | Poor lamination. | Store film and paper only in the original sealed bag. Handle laminate carefully. |
| Film will not slide down ramp smoothly. | Film not loaded properly or wet film-loading ramp. | Make sure film is loaded properly on printmaker ramp (under edge guides); make sure there is not activator on ramp. |
| | Film rake in processor not returned fully. | If printmaker film rake is not fully returned, the rake will interfere with entry of next sheet. |

# CONTROL TECHNIQUES

In the previous three chapters, we've been concerned with making straight enlargements from negatives and slides—enlargements made without the use of any special control techniques. While most color negatives and slides don't require any special printing treatment, the occasional use of a special technique can make the difference between a good print and an excellent one. Let's take a look at a few of the most important controls which you can use to produce high-quality color enlargements.

*Quite often, you can improve the composition of your enlargement by adjusting the easel placement so that the center of interest is away from the center of the picture.*

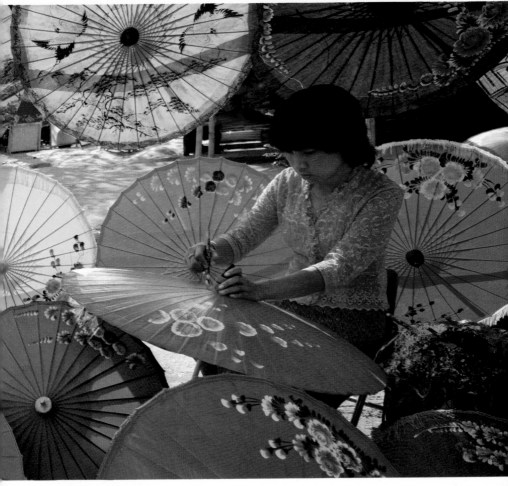

## COMPOSITION

While entire books have been written on composition, a few of the basic points are all that are needed to help you compose a pleasing and interesting color enlargement. For example, it's usually best to have the center of interest a little off-center in the picture but not too near the margins. Also, the horizon line in scenic pictures often looks better above or below the midpoint of the picture, rather than dividing the picture into halves. If the negative or slide that you're printing is lacking in either or both of these compositional qualities, you can probably reposition the center of interest and/or horizon line simply by shifting the position of the enlarging easel.

By moving the easel in this way, you can also usually eliminate areas and details that are unnecessary or distracting. Another way to help your enlargement tell its story simply and clearly would be to enlarge the image more, cropping out distracting areas near the edges.

*You can crop distracting picture elements by raising the enlarger to increase image size.*

# PRINTING-IN AND DODGING

Sometimes the brightness range of a subject is beyond the range of tones that can be reproduced in a print. If you are printing a color negative onto an EKTACOLOR Paper or EKTAFLEX PCT Negative Film, you can partially compensate for an excessive brightness range in two ways: (1) You can give additional exposure to the highlight areas that would otherwise print too light. This is called printing-in or burning-in. (2) You can hold light back from areas that would otherwise print too dark. This is called dodging.

On the other hand, when printing color slides onto EKTACHROME 22 Paper or EKTAFLEX PCT Reversal Film, you must take the opposite approach. Remember that more exposure lightens the image—less exposure darkens it. To darken an area in the print, hold some of the light back during exposure. To lighten an area, you can increase the exposure time (print-in) for that area.

You can easily make your own printing-in and dodging tools from wire, black tape, and dark construction paper or cardboard. When you use these tools, always keep them moving so that you won't be able to see a sharp line on the finished print, indicating where you printed-in or dodged.

*Dodging is one technique for controlling the brightness of an image during printing. For more details, see pages 68 through 71.*

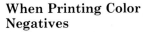

*Typical homemade dodging tools.*

*There any many situations in which printing-in comes in handy. In the print above, made on KODAK EKTACOLOR Paper, flash has slightly overexposed the child in the foreground on the right. Printing-in darkens this area and improves the scene, as in the picture below.*

## When Printing Color Negatives

There are many situations where printing-in comes in handy. For example, when exposing color negatives with flash, foreground objects will probably be much lighter than objects farther from the camera. You can darken the foreground by printing-in. After you've given the print its normal exposure, hold a piece of dark cardboard under the enlarger lens about midway between the lens and the print. Turn on the enlarger and move the cardboard so that only the area of the image which normally would be too light receives additional exposure. If the area you want to darken is small or near the center of the print, it's easier to confine the additional exposure to that area if you do the printing-in with a piece of cardboard in which you've cut a hole. Keep the cardboard in continuous motion so that the increased exposure won't be apparent on the finished print.

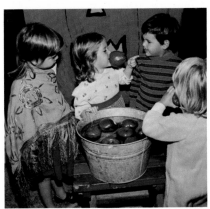

A technically good print of a landscape may be weakened pictorially by light-toned areas which compete for attention with the center of interest. These light areas could be bright stones in the foreground, bright reflections, a white house, a light sky, or some other distracting element. If you're printing a color negative, you can darken such areas by printing-in.

In dodging, you hold back light from the projected image during the

*This is the original picture, printed on KODAK EKTACOLOR Paper. The child's face and nightgown are filled with shadow.*

*Dodging helps to brighten shadow areas, making the child's features slightly lighter.*

basic exposure time so that the photographic paper receives less-than-normal exposure in areas that were too dark in your straight print. The tools used in dodging are also very simple to make. You can cut any shape you need from a piece of dark cardboard and tape it to a piece of wire. Then while you expose the print, hold the cardboard by the wire and move the cardboard over the area of the projected image which is too dark. Keep the wire moving from side to side at the same time to prevent a light line from forming on the print by a shadow of the wire.

## When Printing Color Slides

You can use the same printing controls for enlarging color slides as you would use for enlarging color negatives. Just keep in mind that these controls work in the opposite direction. For example, you can lighten a heavy shadow area by giving it more exposure time than the rest of the picture. To darken a sky, shade (dodge) it with a piece of dark cardboard during a portion of the exposure time.

*Original print on KODAK EKTACHROME Paper.*

*To darken the woman's dress for more detail, this area of the print was dodged during exposure.*

## TEXTURE SCREENS

*This unusual texture effect was made by sandwiching a piece of KODAK Lens Cleaning Paper with a slide, then enlarging them together on a sheet of KODAK EKTACHROME Paper.*

You can make some interesting and unusual enlargements by printing through a texture screen, which is a device that gives the print a textured appearance.

The texture itself can be one of any appealing cloth, wire, glass, plastic, or other material with a grained appearance. Some texture screens are commercially available in the form of film sheets, although you can make others at home yourself. For example, you could make a simple texture screen by tightly stretching a sheet cloth over a frame that you then place over your enlarging easel.

Most texture screens are used in contact with the emulsion of the enlarging paper on the easel. You may need to place a sheet of clear glass over the texture screen to hold it in contact with the paper. You can keep the screen in position during all or part of the exposure, depending on the degree of effect you want. If you want the screen in place for only part of the exposure, divide the total exposure time into parts so that you can remove the screen when the enlarger is off. Don't move the paper between exposures.

*You can add interest to your color prints with texture screens. This print was made with a Mona Lisa texture screen in contact with a sheet of KODAK EKTACOLOR Paper.*

*This print was made on KODAK EKTACOLOR Paper with a canvas-pattern texture screen placed in direct contact with the paper during exposure.*

# PRINT-FINISHING TECHNIQUES

After you've processed your enlargement, there are a number of finishing techniques you can use to add the final touch that can set your photograph apart from others. Some of these techniques are described in the section that follows.

## RETOUCHING

You can retouch a color print with dyes, such as the KODAK Retouching Colors, which are in a semisolid form, or with KODAK Liquid Retouching Colors. Other supplies should include a good-quality spotting brush, water, cotton, and a small ceramic palette.

**Dry-Dye Technique for Large Areas**. You can use this method to apply dry KODAK Retouching Colors over large areas. A set of KODAK Retouching Colors consists of nine jars of colors: red, green, blue, cyan, magenta, yellow, orange, brown, and neutral plus a jar of reducer. Individual jars of colors or reducer are also available.

The technique has two major advantages: You can experiment until the desired effect is achieved before making the retouching permanent, and you can retouch F-surface color prints without losing the glossy finish.

The set of colors should be kept free of water. Dyes containing water will tend to set when applied, making it difficult to remove excess or unwanted dye from the print. Any dry dye can be removed readily by using the reducer. You can use anhydrous denatured alcohol as a substitute for the reducer.

1. To prepare the print for retouching, thoroughly dry the emulsion surface. Clean the surface to be retouched by buffing it with a tuft of dry, clean cotton.

2. To apply the dye, breathe on the cake of retouching color you plan to use. Pick up a generous amount of dye by rubbing a tuft of dry cotton over the cake of dye. With a circular motion, transfer the dye from the cotton to the desired area of the print. Repeat this procedure if you need more color. Smooth out the dye by buffing the area lightly with a clean tuft of dry cotton. You can mix two dyes over one area with this method. Dye on any overlapped area can be removed later. To lighten the applied color over the whole area, or portions of it, continue buffing the surface.

3. To make the dye retouching stable, subject the retouched area to steam for 2 to 3 seconds by holding the print about 10 inches (25.4 cm) from the steam source. When the surface marks caused by the dye application disappear, you have steamed the print sufficiently. Avoid applying too much steam. A small, electric vaporizer is a convenient source of steam.

## Wet-Brush Technique for Small Areas.

For spotting-in dust and other small areas in your enlargements, use KODAK Liquid Retouching Colors.

The wet-brush technique involves the following steps:

1. Using a spotting brush, mix the desired dye or dyes in a palette cup.

2. Add a touch of neutral color to the dye mixture. The neutral dye reduces the brilliance of the pure colors. Keep the dilution weak for good control. It's easier to add more density than to remove excess density.

3. Remove excess dye from the brush on blotting paper, moist cotton, or facial tissue; this will minimize bluish opalescence due to overwetting of the area being retouched.

4. Spot-in the area, making sure that the dye is kept within the confines of the spot. Any overlapping will result in a dark ring around the spotted area.

5. If you've added too much dye, blot the area immediately with blotting paper.

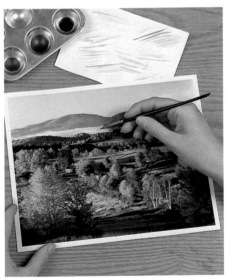

*You can easily spot small areas such as dust spots on color prints with a fine-pointed brush, a tiny amount of liquid retouching dye, and a little water. Apply the dye with a dotting motion until it matches the tone of the surrounding area and the spot is no longer visible.*

*You can remove dust spots and other small defects on color prints with soft-lead, colored pencils, designed for retouching.*

### Pencil Retouching

**On color negative papers:** You can do much of the spotting normally required on color prints with soft, colored retouching pencils. Small spots in the background, dust spots, defects in shadow areas, and even small defects in highlight areas can be corrected quickly with a pencil.

First take care of major retouching, such as large spots or off-color areas, using the dye-retouching techniques previously described. Then before using the pencil, treat the emulsion by spraying the print with a retouching lacquer. (Retouching lacquers are made specifically for this type of pencil retouching. They contain a matting agent which prepares the print surface to accept the pencil readily. Several brands are available at photo-supply stores. Follow the manufacturer's instructions.)

**On color reversal papers:** Black spots on the print are usually due to dust on the slide. Apply white opaque to the black spots on the print. After the opaque dries, you can apply colored pencils to match the color of the surrounding area. Spray the opaqued print with lacquer designed for photographic applications to restore even surface reflection.

## MOUNTING

A mount separates a picture from its surroundings and therefore emphasizes the picture. Usually a special mounting material, called mounting board, is used for this purpose. A well-chosen mount directs attention to the picture, not to itself. Photographers often use material like KODAK Dry Mounting Tissue, Type 2, for mounting their prints. Here's how to mount a print:

*Most photographers use a material such as KODAK Dry Mounting Tissue, Type 2, for mounting their prints. Tack the mounting tissue to the center of the back of the print.*

1. Tack the heat-sensitive tissue to the center of the back of the print, using a tacking iron or a household iron. (Set a household iron at the lowest setting in the synthetic-fabric range and adjust if necessary.)

2. Trim the print and position it on the mounting board. Holding the print in place, lift one corner of the print and tack the mounting tissue to the mount. Do this on all corners.

3. If you plan to use a dry-mounting press, be sure to protect the print with a double thickness of heavy kraft wrapping paper. Before you put the print into the press, make sure that the kraft paper is completely dry. Close the press on the kraft paper two or three times (at approximately 2-second intervals) before closing it for the mounting step.

4. Close your print inside the press for at least 30 seconds. The amount of time required for dry-mounting is that which allows enough heat to penetrate the print-tissue-mount sandwich and activate the adhesive. In general, 30 seconds' time is enough.

5. Remove the mounted print from the press, place it face down on a clean, smooth surface, and keep it flat until cool. A heavy book or other flat weight is useful for this purpose.

6. If you don't have a mounting press, you can use a household iron to do your mounting. Use the same setting on the iron as suggested for tacking the mounting tissue to the print. (See step 1.) Cover the print with a double thickness of dry kraft paper and run the iron back and forth over the covered print. Keep the iron moving, and work from the center of the print toward the edges. Don't push down too hard or you could mar the surface of the print.

*Holding the print in place, lift one corner and tack the mounting tissue to the mount. Do this on all four corners.*

# TIPS TO REMEMBER

*Your negatives and slides will stay clean
and unharmed when you file them properly.*

Don't run off without filing your slides and negatives safely for future use. For relocating a particular subject, it's a good idea to include an identifying number on the back of each print and on the slide or negative envelope.

Also, the cleaning chore in the darkroom will be much easier if you do it right away. Be sure to wash all the containers and trays you used, and rinse the thermometer, too.

Remove any chemical splash marks from the splashboard behind your sink, from adjacent counters, or from the floor. Fixer spots, for example, in

addition to looking messy, can turn to powder when dry and become airborne. If fixer dust settles on photographic paper or film emulsion surfaces, it will cause small spots called "pinholes" on the emulsion.

The towels you used should be washed before your next film processing or printing session. This will help eliminate another possible source of mysterious spots and fingerprints on your pictures. As you leave, check to be sure that all the electric lights, including the safelight, enlarger lamp, and enlarger controls, are turned off.

78

# STORAGE AND CARE OF PROCESSED COLOR MATERIALS ■

## Preserving Color Prints

Color prints are everywhere: in wallets, on walls, in albums, on desk tops. Sometimes great care is taken in their preservation; sometimes, no care at all. Prints are widely accepted because they can be viewed at any time, without special equipment, and because in most cases they can be replaced before they fade or become damaged. There are instances when the negative from which a print was made is not available to make reprints. In those cases, the care of the print becomes very important.

*Provide a cool, dry, uncontaminated storage place.* If you have prints that you do not expect to display, or that you wish to store for a long time before you display them, it is advisable to leave them unmounted. The reason for this is that unmounted prints occupy less space and involve fewer materials that might prove deleterious to the images. Store them in the dark, at 0°F (−18°C) or lower. Condition the prints at room temperature and 25 percent relative humidity before sealing them in KODAK Storage Envelopes. Prints larger than 8 x 10 inches can be protected from moisture by using three wraps of aluminum foil and sealing the folds and seams with moistureproof tape such as plastic electrical tape (not what is called "friction tape"). If several prints are stored in one package, interleave them with archival quality paper. Do not store color materials in the same enclosure as black-and-white materials.

*Use care in mounting and displaying prints.* Starch paste, animal glue, and rubber cement should not be used for mounting prints. Some synthetic adhesives could be used for mounting small prints, but dry mounting is preferable for all sizes because the adhesive tissue provides a barrier between the mount, which might contain impurities, and the print itself. Interleave prints that are stored back to front or face to face with archival quality paper. Prints that are handled frequently should be protected with a sleeve or sheet of transparent material such as cellulose acetate or polyester (both without surface coating). If the prints are framed, they can be protected by a sheet of glass or by a sheet of rigid plastic that has been made so that it absorbs ultraviolet radiation. Prints cannot always be displayed in a way that promotes long-term keeping. The best practice is to display them in subdued light, such as normal household lighting, as far away from the light source as possible and away from direct sunlight. Whenever possible keep the temperature under 70°F (21°C) and the relative humidity under 50 percent. Avoid atmospheres that contain damaging chemicals or fumes. If less than ideal conditions are unavoidable, make an exhibition print, with the realization that its life is limited.

*For convenient access, store prints in albums.* A less elaborate way to keep prints, but one which combines ready access with good long-term storage potential, is a photo album. To get the best results from storage in an album, keep it in a place that does not exceed comfortable room temperature and humidity. A book shelf or metal drawer is a better storage place for the album than a wood drawer because furniture occasionally is contaminated with photographically harmful fumes from mothballs, mildew inhibitors, wood preservers, paints, varnishes, and wood glues.

## Preserving Color Negatives and Slides

- Keep them clean.
- Protect them from light.
- Keep them in a cool, dry place, preferably in a refrigerator.
- Use metal storage containers.
- Keep away from harmful gases.

## Processing Affects Keeping

Commercial processing laboratories are aware of the important part that processing plays in the stability of prints, slides, and negatives. If you do your own processing, remember that failing to follow the manufacturer's processing recommendations can impair image stability; for example, insufficient time in certain solutions or inadequate rinsing or washing can leave unwanted chemical residues.

Here are some examples of gases or vapors that can be harmful to photographic products: industrial gases, motor exhausts, paints, solvents, cleaners, mothballs, formaldehydes, chipboard, glues, mildew preventatives, foam-in-place insulation, fabric treatments such as permanent press and stain inhibitors, insecticides, and sulfides.

For more information about storing photographic materials, send for KODAK Publication No. E-30, *Storage and Care of KODAK Color Materials.* Single copies of E-30 are available free of charge. Address your request to Eastman Kodak Company, Department 412-L, Rochester, NY 14650. Another useful KODAK Publication, F-40, *Conservation of Photographs*, is available through your photo dealer.

# KODAK
# PHOTO BOOKS
# AND GUIDES

The following Kodak photo books will provide you with many ideas for new and different picture-taking techniques and present a wealth of reference material to help you in your darkroom. These and other Kodak photo books on a variety of photographic topics are available through your photo dealer. For a list of current titles and prices send for a free copy of "Photography Books from Kodak" (L-7K). Address request to: Dept 412-L, Eastman Kodak Company, 343 State Street, Rochester, New York 14650.

## Building a Home Darkroom
(KW-14)

A complete coverage of the steps and equipment needed for building an advanced home darkroom. Treatments include electricity, plumbing, construction and safety. Possible locations and special situations are discussed, and the construction of a darkroom erected in the basement of an older home is outlined step by step. Contains 96 pages and approximately 150 color photos.

## KODAK Pocket Guide to 35 mm Photography (AR-22)

Designed to be carried in a pocket, this book provides the photographer with on-the-spot information. In addition to explaining camera, flash, and filter operation, it gives a variety of tips with chapters on action, nature, people, existing light, landscapes, zoos, special effects, and more.

## Darkroom Expression (KW-21)

Brings technique and imagination together into an easy-to-follow, illustrated text. Steps beyond basic darkroom techniques into the areas of making high-contrast derivations and posterizations, creating the Sabattier Effect, adding color and texture, printing without negatives, and more.

## Black-and-White Darkroom Techniques (KW-15)

Here's a book that details all the needed steps for developing, printing, and finishing black-and-white photos according to the reader's personal taste.

## The Art of Seeing (KW-20)

Here's *the* book to open your eyes and relax your mind. It shows you how to avoid preconceptions that inhibit seeing, how to increase awareness of subjects around you, how to vary the ways you see, how to mold technique to subject, and how to see as the camera and lens see.

## The Joy of Photography (AC-75S)

Information every photographer wants on: increasing visual perception; understanding and using cameras, films, lenses, and filters; learning the techniques of successful photography; darkroom processes; and much more. 312 pages with more than 500 pictures.

## KODAK Complete Darkroom DATAGUIDE (R-18)

Complete reference information for processing and printing using black-and-white and color films, papers, and chemicals. Includes instruction book, wall charts for printing from negatives and printing from color transparencies, two calculator dials to do common darkroom calculations, and more!

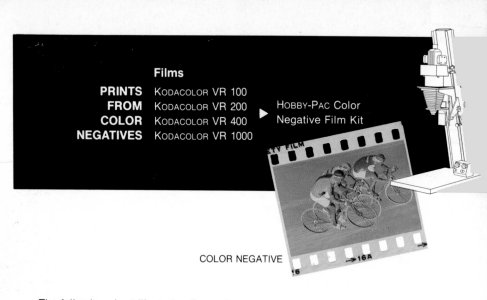

## Films

| | | |
|---|---|---|
| **PRINTS** | KODACOLOR VR 100 | |
| **FROM** | KODACOLOR VR 200 | ▶ HOBBY-PAC Color |
| **COLOR** | KODACOLOR VR 400 | Negative Film Kit |
| **NEGATIVES** | KODACOLOR VR 1000 | |

COLOR NEGATIVE

The following chart illustrates the route for making prints from color negatives and transparencies. Individual control is offered via the choice of film, printing processes, and papers.

This easy to follow illustration allows you to select the process most suited to your needs.

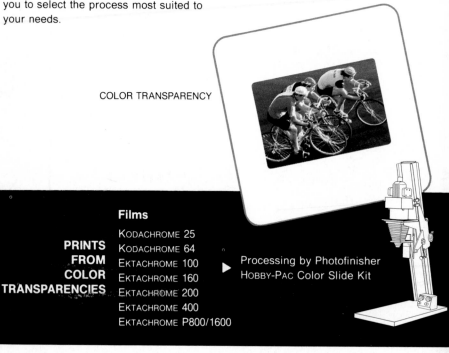

COLOR TRANSPARENCY

## Films

| | | |
|---|---|---|
| | KODACHROME 25 | |
| **PRINTS** | KODACHROME 64 | |
| **FROM** | EKTACHROME 100 | ▶ Processing by Photofinisher |
| **COLOR** | EKTACHROME 160 | HOBBY-PAC Color Slide Kit |
| **TRANSPARENCIES** | EKTACHROME 200 | |
| | EKTACHROME 400 | |
| | EKTACHROME P800/1600 | |